Miró

Joan Miró

Ediciones Polígrafa

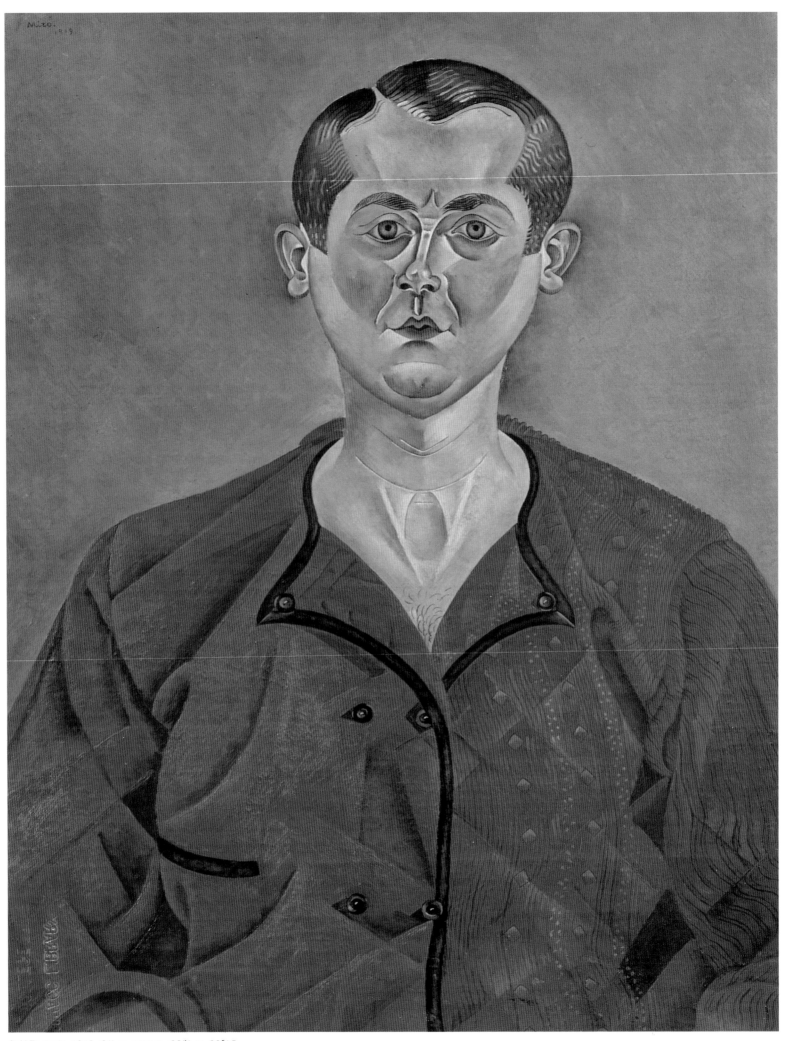

Self-Portrait, *1919. Oil on canvas, 28¾ × 23⅝"*
(73 × 60 cm). Musée Picasso, Paris

Miró's Universe

To judge by the year he was born, 1893, Joan Miró belonged to the second generation of modern artists, those who came of age after the Post-Impressionists, the Fauvists, and even the first Cubists had already made their contributions. Perhaps because of this, Miró was able to employ the language of modern art in his work from the outset, without the trauma that somewhat older artists experienced when they had to break with traditional ways. In this regard, it is worth noting that not a single exercise in academic painting from Miró's formative years is known. His youthful attempts from before 1920, when he began to define his own style, already show an awareness of Fauvism and Cubism.

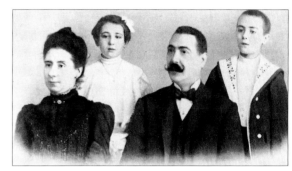

Joan Miró with his sister and their parents, Miquel Miró i Adzerias and Dolors Ferrà, the daughter of a cabinetmaker from Palma de Mallorca.

A Unique Artist

Miró's themes and symbols and his characteristic pictorial signature are personal and unmistakable, but this originality did not isolate him from the art of his era. Instead, it made him one of those unique individuals without whom twentieth-century art would have been a very different thing.

Miró was trained in the Barcelona of the first two decades of this century, a center of early modernism that was in close touch with the most recent artistic developments in Paris. It was in Barcelona that he became familiar with the avant-garde. The influence of Paul Cézanne, the Fauvists, and the Cubists reached Miró through exhibitions before and during World War I at Josep Dalmau's gallery (where his own work would be shown for the first time in 1918). And in 1917 he met Francis Picabia, one of the central figures of Paris Dada, who at that time frequented Barcelona.

Miró's work cannot be neatly categorized within any of the larger trends or movements of the historical avant-garde, although his close contact with André Breton and the Surrealists beginning in the mid-1920s was a decisive factor in his search for a personal pictorial style. Strictly speaking, however, he was not a Surrealist painter, at least not in the same sense as Max Ernst, Yves Tanguy, René Magritte, or even Salvador Dalí. Miró never painted dreams, for example, nor did he practice the technique of automatic writing, which the Surrealists invented as their principal way to free the subconscious.

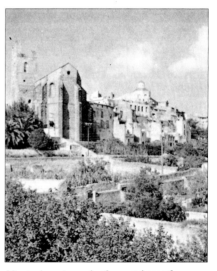

Montroig, a town in the province of Tarragona, was important in the life of Miró. It was there that he decided to devote himself to painting.

Peacock, c. 1908. This drawing, made by Miró in his youth, was the design for a brooch.

The Power of the Land

Miró's interests lay in another direction. The source of his pictorial universe was his bond with the land and with its primal elements. He felt an intense, almost supernatural communion with the particular settings of Mallorca's Mediterranean landscape and the village of Montroig in the

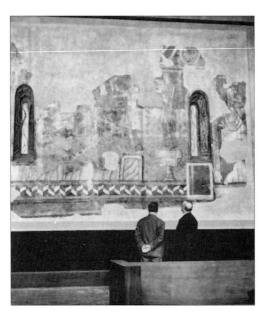

Joan Miró and Josep Llorens Artigas before a Romanesque fresco in the Museu de Arte de Catalunya, Barcelona.

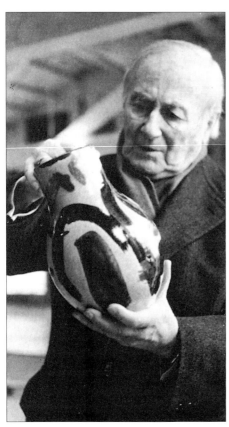

Joan Miró was interested in ceramics from the time he met the craftsman Josep Llorens Artigas in 1915.

province of Tarragona. Miró's intimate understanding of nature is that of a peasant farmer, although he was born and raised in the cosmopolitan environment of Barcelona. The exaggeratedly large feet seen on many figures in his paintings convey his conviction that we derive strength from the ground we walk on, in the same way that a tree takes in nourishment through its roots. This earthly energy, which, he felt, illuminates and transforms the reality we see, is what Miró attempted to reveal in the meticulously rendered details of *The Farm* of 1921–22 (plate 10). By legitimizing fantasy and the subconscious as areas available to artists, Surrealism gave Miró the opportunity to express concerns like these as universal archetypes.

A Personal Universe

In this way, Miró during the twenties and thirties created an unmistakable vocabulary of symbols and ideograms; at the same time, he established a new idea of what the space inside a painting could be like. He did all of this naturally, almost without setting it out as a goal. While the springboard from which he took this leap was Surrealism, he made use of it in much the same way he earlier had made use of Fauvist colors and the spatial order of Cubism. With the series of works called the Constellations, painted in 1940 and 1941, Miró made this new pictorial space absolutely his own, and populated it with his archetypal characters, such as the woman, the star, and the bird. This space, though it seemed to continue past the edges of the painting, was still only a fragment of the universe imagined by the painter, a world having its own nature and governed by its own rules.

Artistic Maturity

It is not surprising that around the time of World War II, with his international reputation confirmed, Miró began using larger formats that went beyond the traditional realm of easel painting. In doing so, he put himself one step ahead of the fundamental discoveries that would be made by postwar painting, especially in the United States, and left his mark on the course of contemporary art.

Miró continued to search and experiment. His pictorial world itself did not change very much once he had created it, but his curiosity about new artistic techniques and materials was endless. The universality of his artistic language enabled him to work in a variety of media outside of painting, from mosaics to ceramics and from sculpture to tapestries. Even beyond his own work in these fields, his influence on areas such as graphic design was considerable.

Miró did not found an artistic "school," in the classic sense of the word, but it is difficult to imagine what the painting of our era would have been like without him.

Joan Miró / 1893–1983

Although he was born in Barcelona, in 1893, Joan Miró's life was tied from childhood to Mallorca, his mother's home, and to the region of Tarragona—first Cornudella, where his father was born, and later the village of Montroig. At eighteen he decided to devote himself to painting in an environment dominated by the latest French artistic trends, which he was able to observe firsthand as early as 1912 in the Cubist exhibition at the Dalmau gallery. These influences, together with those of Paul Cézanne, Vincent van Gogh, and Fauvism, are the most noticeable ones in his early works, from 1915–18, in which he already showed an affinity for figures and landscapes related to the rural world of his summers in Montroig. His identification with that world is the theme of a series of works carried out in the following years, works whose style has been called "detailist" because of their attention to minute descriptive detail in the treatment of objects and figures.

The Search for a Language

This early period culminated in *The Farm* of 1921–22 (plate 10), a seemingly naïve yet transcendental, almost religious inventory of his family's farm in Montroig, a painting which was very much influenced by the Romanesque frescoes he had seen at the Museu de Arte de Catalunya in Barcelona. He then settled in Paris, which he had previously visited in 1920. During the winters, the sculptor Pau Gargallo let him use his studio on the rue Blomet, near the Bal Noir, an establishment that was a meeting place of the artists and writers who, from 1924, would fill the ranks of Surrealism, including Michel Leiris, Georges Limbour, André Masson, Robert Desnos, and Antonin Artaud. Miró, who would already have known of this milieu through Picabia, whom he had met in Barcelona, became friendly with André Breton and exhibited regularly with the Surrealists beginning in 1925.

The Surrealist Influence

Despite his loyalty to the group, Miró was never an orthodox Surrealist. In *Harlequin's Carnival* of 1924–25 (plate 11), *Head of a Catalan Peasant* of 1924–25, and many other paintings of the twenties and thirties, he took advantage of the new areas of fantasy and dream that Surrealism had won over for artistic practice. He used them to serve his interest in the mythical qualities of the land, already present in *The Farm*. The Surrealist taste for sexual and scatological motifs and for arcane symbols is always charged in Miró's art with the steadying sense of the earthly that accompanies all his work, purifying and simplifying it. The construction of his paintings still owed much to the spatial grammar of Cubism, as seen in *Dutch Interior I* of 1928 (plate 16). Even more, his painting was greatly influenced by the Fauvist juxtaposing of planes of pure color, as in *Painting Based on a*

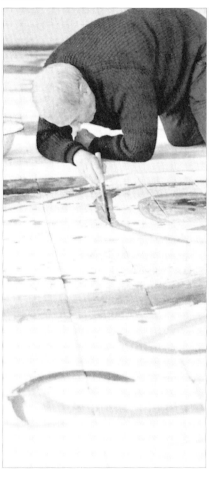

Miró knew how to attain the same spontaneity in his paintings and in his large murals, most of which were done in ceramic.

Snake, *1908. In Josep Pascó's school, the young Miró made this drawing as a design for a piece of jewelry.*

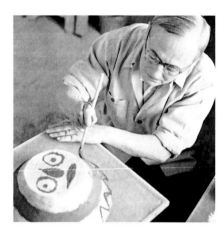

In his later years, Miró continued to explore other forms of expression, including sculpture and ceramics.

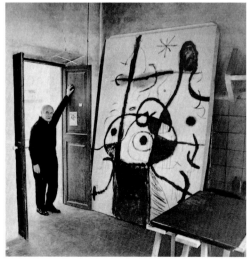

The painter dreamed for years of having a large studio, and finally obtained one in 1956 in Palma de Mallorca.

Collage of 1933 (plate 17) and *Woman and Dog in Front of the Moon* of 1936 (plate 24). Pictures like these demonstrate his skill at incorporating diverse elements of avant-garde practice into his own artistic language.

The Constellations

Until 1936, Miró alternated his stays in Paris, where he sometimes had to get by on very little money, with periods in Montroig and Mallorca. Some of his paintings of this time seem to express his experience of economic hardship and, subsequently, his feelings about the Spanish Civil War. The most dramatic among them was *The Reaper*, painted for the pavilion of the Spanish Republic at the 1937 World's Fair in Paris and exhibited there along with Picasso's *Guernica*. The work later disappeared.

But in 1940, in the small Normandy town of Varengeville, where Miró had gone to flee the war, he reached a turning point in his career by beginning to paint twenty-three small compositions on paper. These paintings in gouache, called the Constellations, were inspired by contemplation of the starry sky over the Normandy coast. In them, small pictograms evenly cover the painted surface all over. In this way, the painting can be imagined as continuing beyond the edges of the sheet of paper. In the Constellations, Miró not only purified his characteristic pictorial symbolism, but also discovered a new concept, the "all-over" picture, which became a precursor for much postwar abstract painting.

In 1940, Miró returned to Spain, and a large retrospective exhibition at the Museum of Modern Art, New York, the following year brought him international recognition at the moment in which he had reached true artistic maturity. After that, Miró continued deepening and refining his personal language and experimented with new media and techniques with ever greater confidence. His interest in sculpture grew, and in the 1940s and 1950s he collaborated regularly with Josep Llorens Artigas on ceramics. Works commissioned in the United States made it possible for him to undertake projects in large formats. These led in turn to the ceramic murals that were to occupy much of his time beginning in 1958, when he created two of them for the UNESCO Building in Paris. During the same years, he began to make designs for tapestries and textiles in collaboration with prominent craftsmen.

New Challenges

From 1956 until his death in 1983, while international recognition of his art continued to grow, Miró lived quietly in Palma de Mallorca. There, he was finally able to realize his dream of being able to work in a large, spacious studio, which the architect Josep Lluís Sert designed for him in 1956. In 1975, the Fundació Joan Miró opened in Barcelona. Following the artist's wishes, it became a center for the active promotion of contemporary art. Despite universal acclaim for his work, Miró's search for new artistic challenges never ceased. The proof of this lies in his designs for the 1978 theater work *Mori el Merma* and in his last sculpture, the monumental *Woman and Bird* (plate 72) that today stands in a park named for him in his native city.

Plates

Early Contact with the Avant-Garde

Miró's work began under the influence of modern French painting—Post-Impressionism, Fauvism, and Cubism—which was shown during his youth in Barcelona at the gallery of Josep Dalmau. No academic exercise from Miró's early years is known, not even the customary copies of classical works. Instead, Miró opened his work by making use of whatever most interested him among the different avant-garde styles. *"Nord-Sud"* ("North-South"), a title he took from a French magazine (plate 1), is a good example of this. The Fauvist influence is seen in its thick brushstrokes and explosion of color, but some areas are also reminiscent of Robert Delaunay's paintings of solar disks. The influence of Paul Cézanne is evident in some of the objects that make up the still life, but the inclusion of lettering in the painting came from the Cubist works of Pablo Picasso, Georges Braque, and Juan Gris.

1

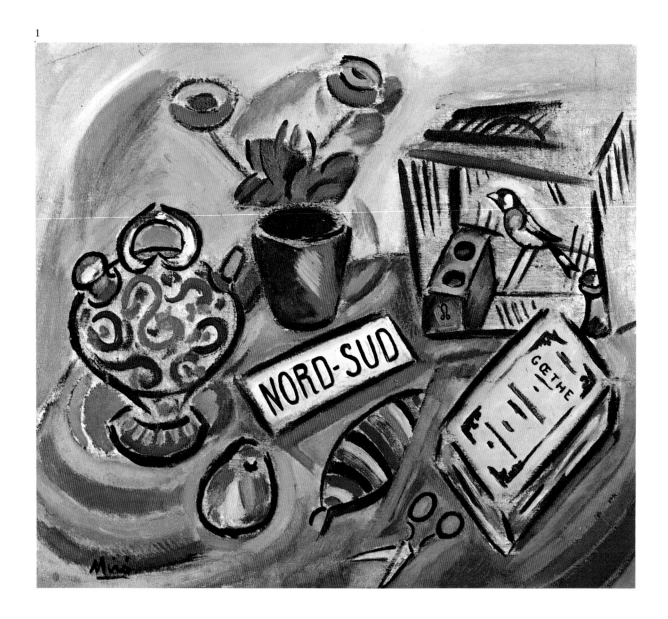

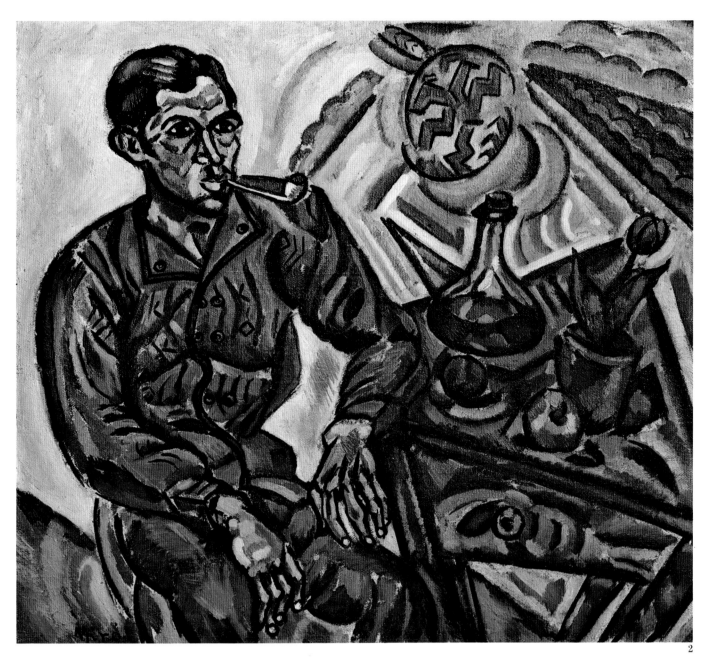

2

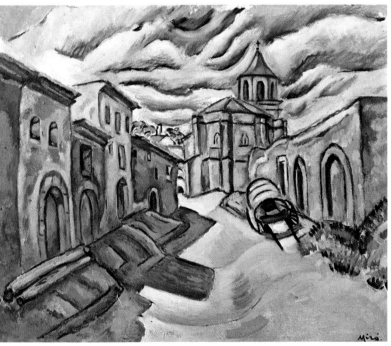

3

1 "Nord-Sud," *1917. The integration of
lettering into the painting is something
that Miró learned from the Cubist works of
Picasso and Braque.*

2 Portrait of Vicente Nubiola, *1917. The
color and the aggressive expressiveness,
of Fauvist origin, merge with a spatial
treatment of the still life on the table that
is closer to Cézanne and to Cubism.*

3 A Street, Prades, *1917. The colors and
the turbulent sky recall the work of Vincent
van Gogh.*

4 Ciurana, the Village, *1917. The way a sense of volume is created through color, reinforced with darker brushstrokes, recalls Cézanne's landscapes or those that Picasso painted in the first decade of the century in the town of Horta de Ebro, at the very beginning of the Cubist adventure.*

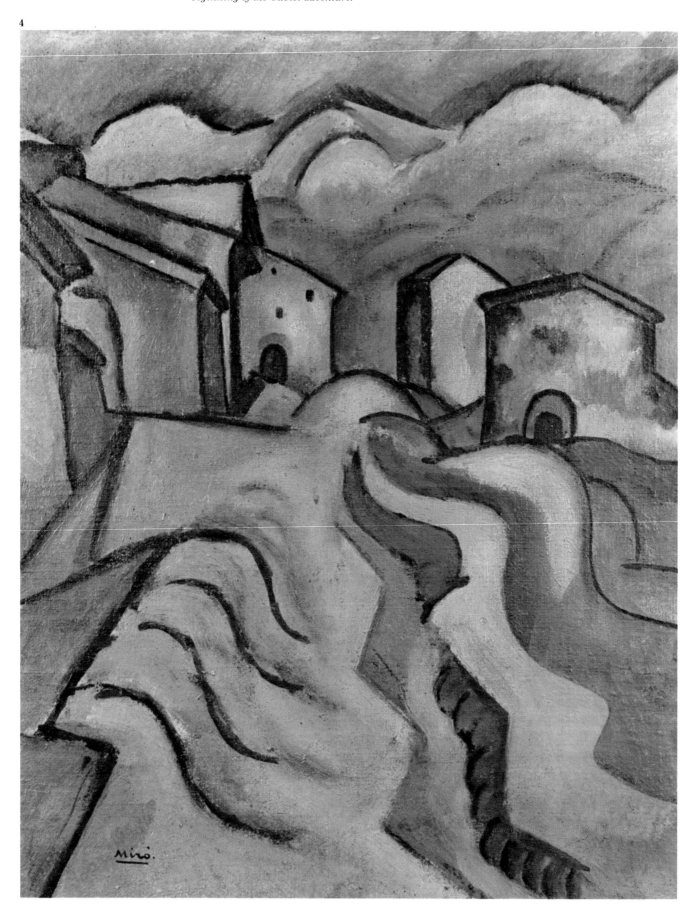

5 Design of a Poster for the Magazine "L'Instant," *1919. L'Instant was an avant-garde magazine published in both Paris and Barcelona. The poster design, which was never printed, is an inventory of the dominant styles in the painting of that time.*

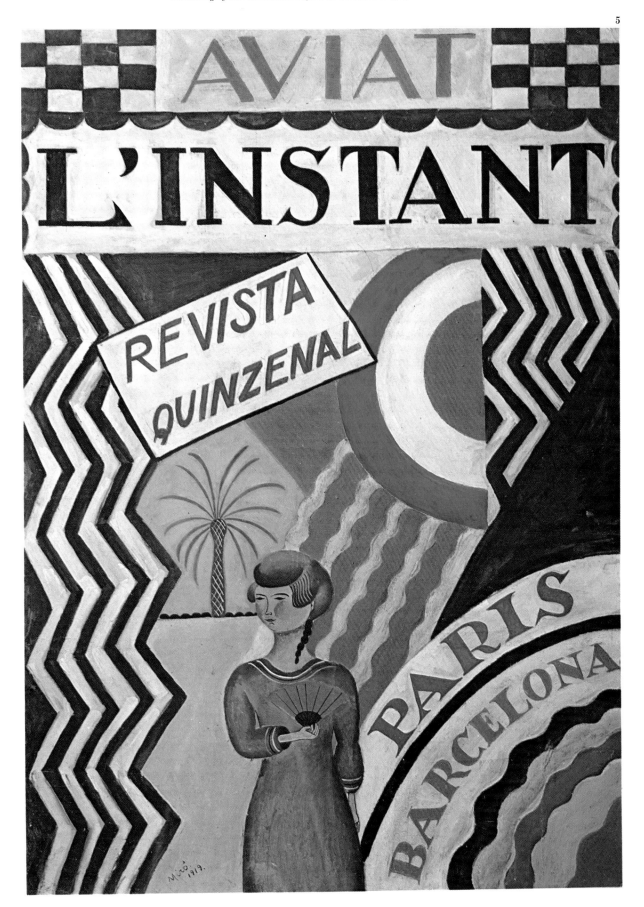

The Farm

One of the threads running through Miró's work is his sense of something almost supernatural in the land, from which he felt he derived his vital energy in the same way that a tree does through its roots. Although he was born in Barcelona, from childhood he often visited Mallorca, his mother's home; Cornudella (in the province of Tarragona), where his father was born; and later Montroig, where the family bought a farm. Miró's feelings toward these particular places are strongly present in a series of paintings done between 1918 and 1924. The paintings are often described as "detailist" because of the minute inventory of the rural world that the artist undertook in them. The diverse landscapes and objects always appear under an intense, uniform light, as if illuminated by some mysterious energy of the earth. *The Farm* (plate 10), painted on Miró's return from his first trip to Paris, culminated this stage, which immediately preceded the decisive influence exerted on his work by Surrealism, beginning in 1924.

6

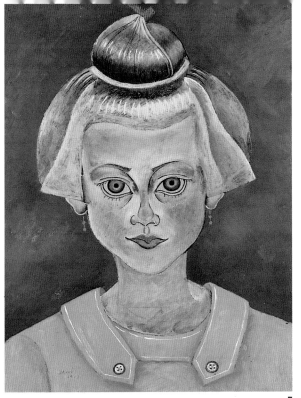

6 The Village of Montroig, *1919. Although the influence of modern French painting can be seen in the color and the handling of space, the detailed treatment of objects already belongs to the pictorial universe unique to Miró.*

7 Portrait of a Young Girl, *1919. Portraiture was never Miro's principal interest. This work suggests what he learned from the Romanesque paintings that had so impressed him in his youth.*

8 Vegetable Garden and Donkey, *1918. The trees, the bird, the plowed land, and the house are painted as if seen for the first time.*

7

8

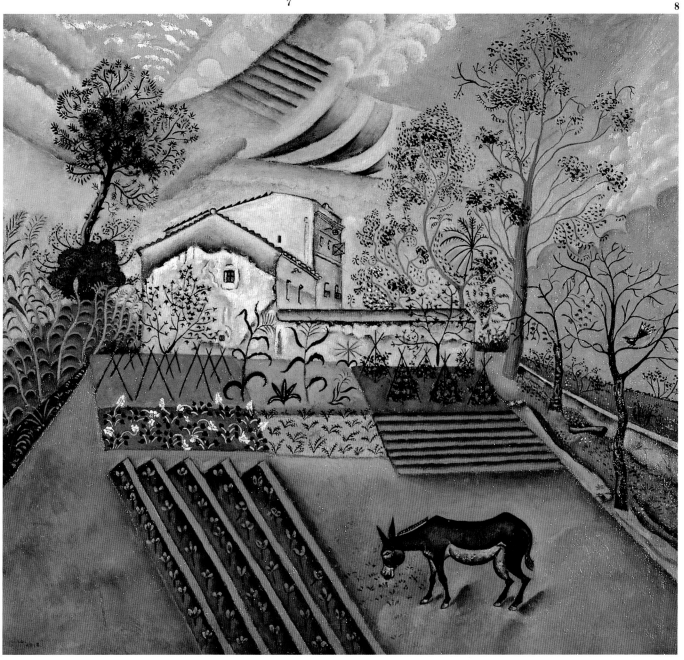

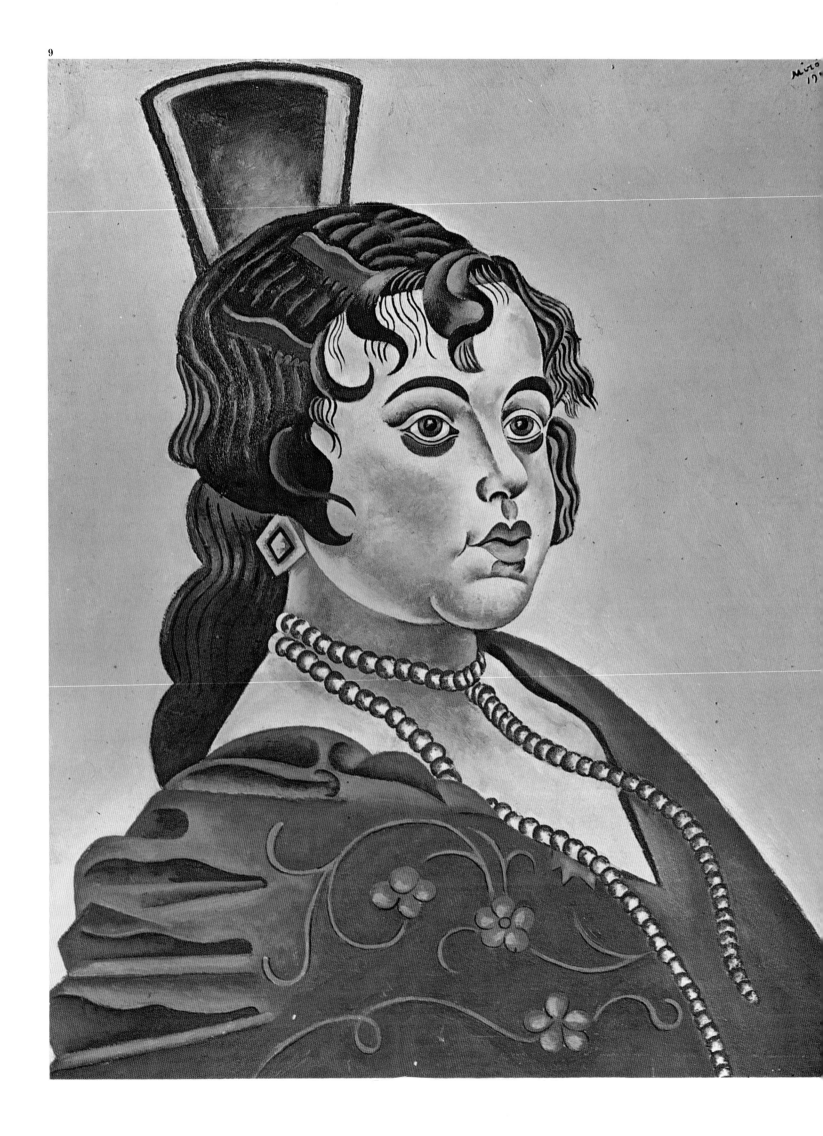

9 Portrait of a Spanish Dancer, *1921. The portraits from these years look almost like icons. In them, the almond-shaped eyes and the sharply outlined noses are reproduced almost exactly from medieval Catalan paintings.*

10 The Farm, *1921–22. Miró's mythological sense of the land is at the center of his work. His personal universe is summed up in this painting, which depicts the farm that his family bought in 1910 in Montroig. Its composition in horizontal strips, taken from Romanesque Catalan painting, and the naïve, exact style used for the animals and objects are the keys to Miró's pictorial style. Soon he would refine it, after coming into contact with Surrealism.*

10

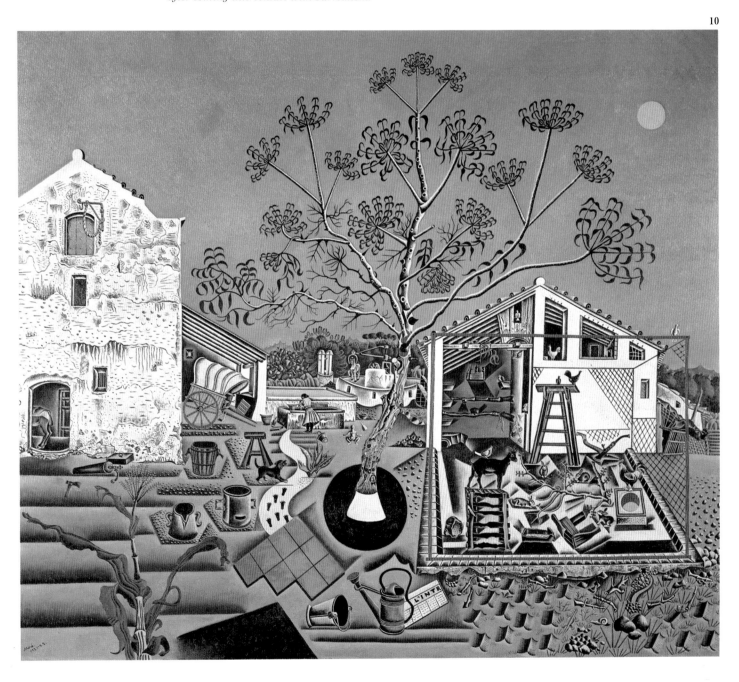

Surrealist Experiments

When Miró moved into the studio of Pau Gargallo on the rue Blomet in Paris, he came in contact with the poets and artists belonging to a group that had arisen from Dadaism. In 1924, this became the Surrealist group centered on the poet André Breton. Miró was never an orthodox Surrealist. However, the movement legitimized the use of dreams and the subconscious as artistic raw material. It thus offered him the possibility of liberating his own pictorial style by allowing him freely to combine the earthly and the magical elements seen in his "detailist" period. *The Tilled Field* (plate 12), which is a simplified version of *The Farm*, and *The Hunter (Catalan Landscape)* (plate 13) are good examples of this change, which would reach full development in *Harlequin's Carnival* (plate 11). The world of the imagination and the subconscious, rather than being an end in itself, was for Miró a way of giving shape in his paintings to his lived experiences and his memories.

11

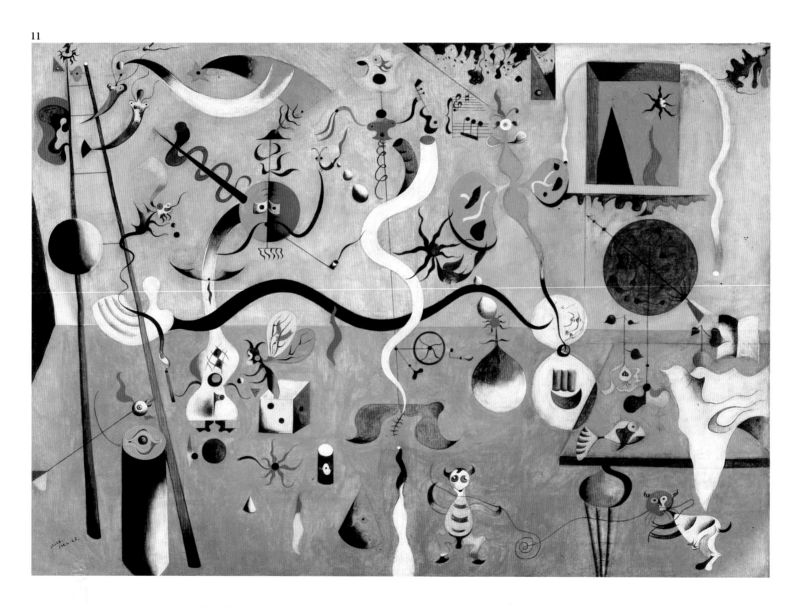

11 Harlequin's Carnival, *1924–25. One of the great attractions at the first Surrealist exhibition, in 1925 at the Galerie Pierre in Paris, was this work, the first of Miró's fully to take part in the new aesthetic.*

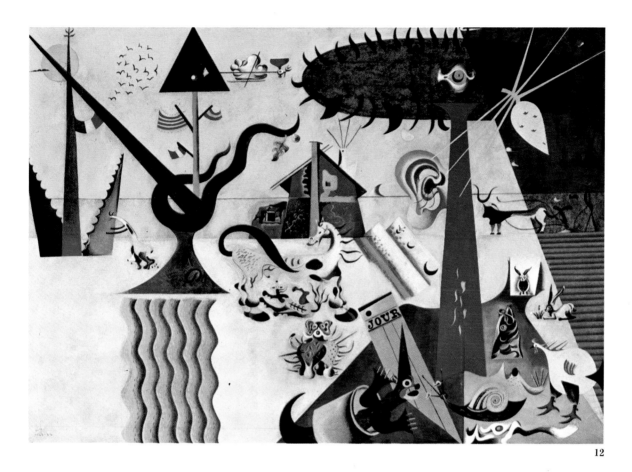

12 The Tilled Field, *1923–24. The house, the tree, and some of the figures come directly from* The Farm *(plate 10), but Surrealist elements, such as the eye and the ear near the tree, have been added.*

13 The Hunter (Catalan Landscape), *1923–24. Two wide planes of color allude to the sky and the earth. The letters in the lower right-hand corner refer to the sardine skeleton at the bottom of the composition.*

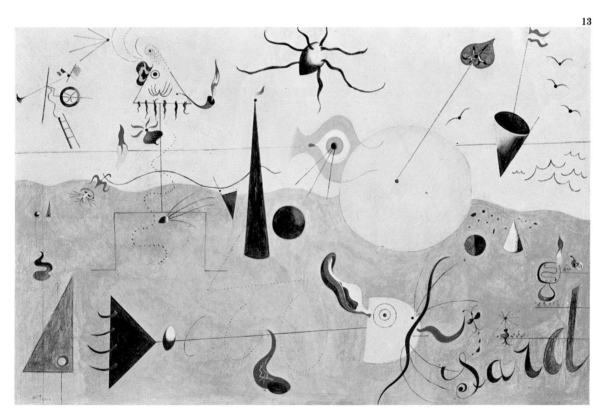

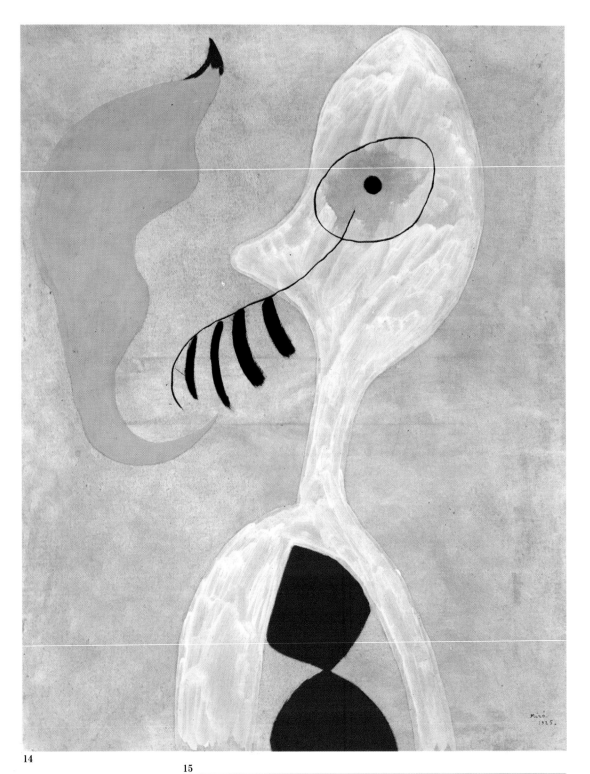

14

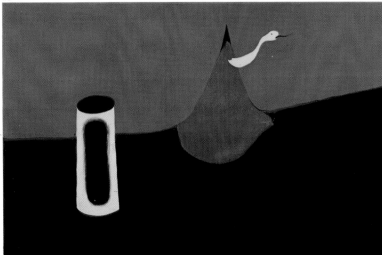

15

14 Head of a Smoker,
1925. *Light blue back-*
grounds are common
during this period. The
Surrealist influence can be
seen in the conception of
the figure.

15 Landscape with
Snake, *1927. The horizon*
line dividing the surface
in two relates the painting
to concrete visual
experience.

16 Dutch Interior I,
1928. In 1928 and 1929,
Miró realized several
paintings based on works
by the Old Masters.
In this case, it was
H. M. Sorgh's The Lute
Player. *Within a very*
controlled composition,
the characters and motifs
of the original were
utterly transformed. Miró
used the language of
shapes and lines and
colors to remake reality
and turn it into a strictly
pictorial universe.

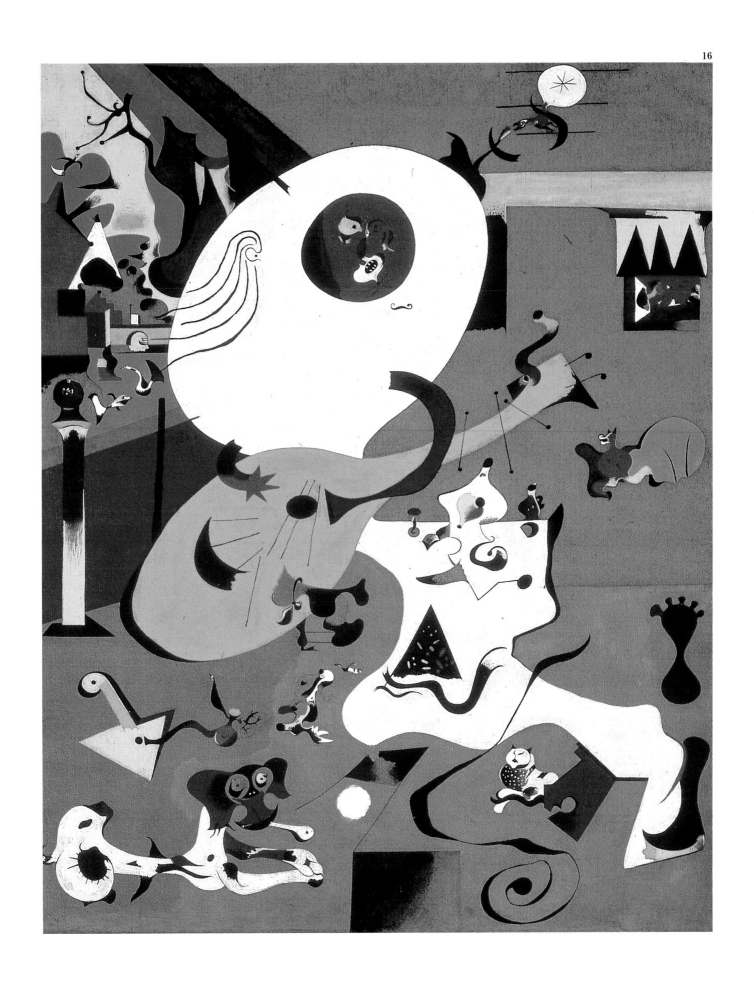

Personages

Once Miró had assimilated the advances of the Surrealists, he created his own iconography, paying special attention to the human figure. From 1929 to 1938 he produced a series of works, marked by free and confident brushstrokes, in which flat colors and simple shapes reconstruct the world. Collage suggested to him new shapes that could be transferred onto the canvas (see plate 17). The backgrounds in this period are often dark, perhaps a sign of the spiritual disturbance caused by the approach of war. *Painting on Masonite* (plate 21) belongs to a series of wild, violent paintings that allude to the Spanish Civil War. *Man and Woman in Front of a Pile of Excrement* (plate 20), *Woman and Dog in Front of the Moon* (plate 24), and *"Une Étoile caresse la sein d'une négresse"* (plate 22) are some of the works in which the dark backgrounds characteristic of this period are especially noticeable.

17

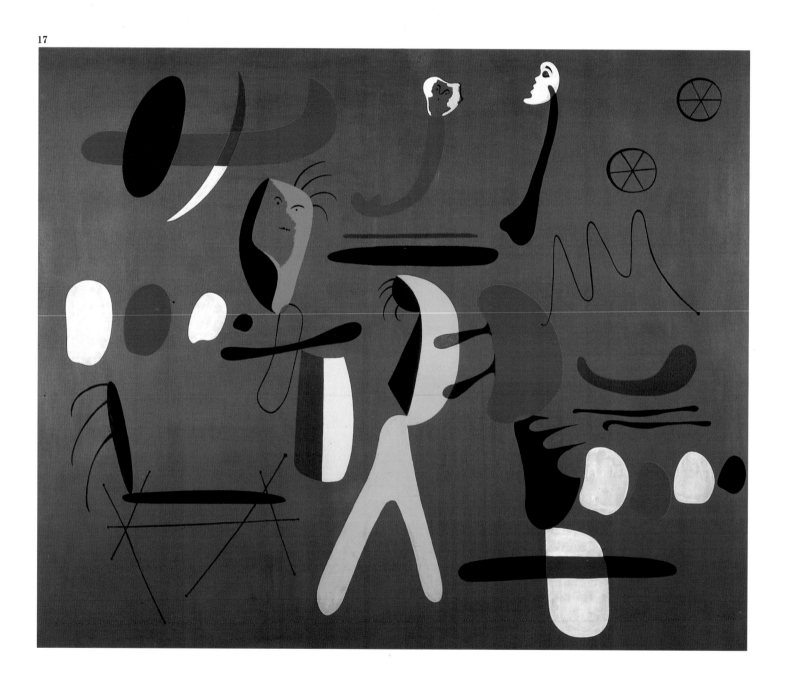

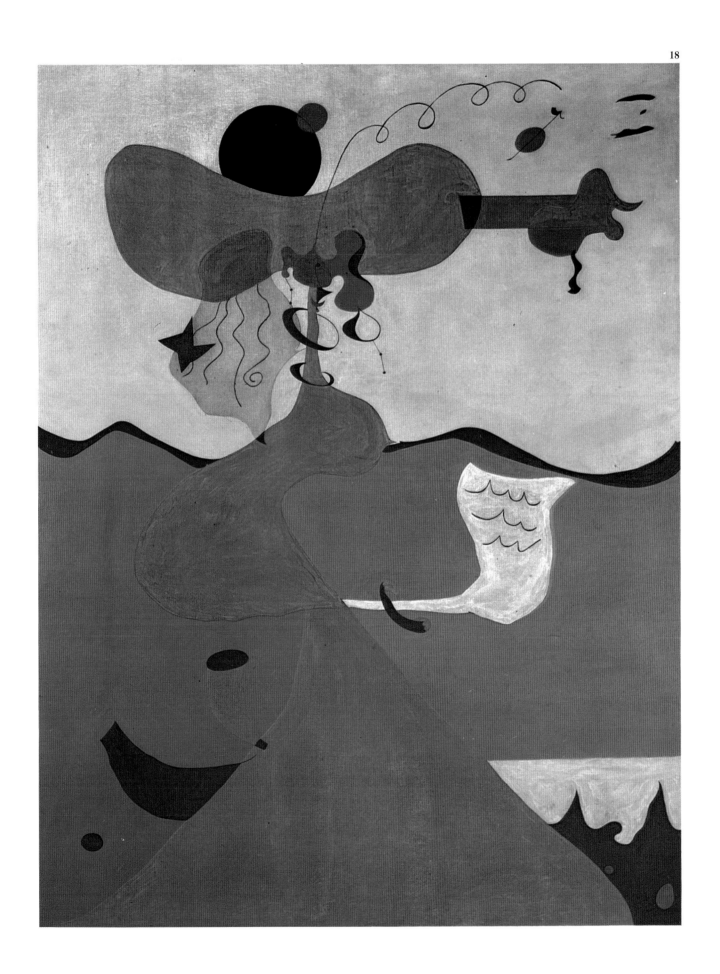

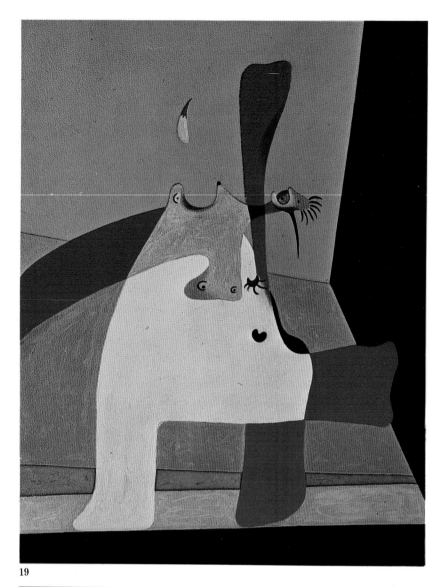

19, 20 Flame in Space and Nude Woman, *1932;* Man and Woman in Front of a Pile of Excrement, *1935. The contortions of the figures and the tense, anguished tone of the compositions contrast with the meticulous, painstaking execution. This paradox is characteristic of many paintings of this critical era, in which Miró was developing his artistic language.*

21 Painting on Masonite, *1936. This is one of a series of twenty-seven aggressively executed paintings done on masonite. They allude to the Spanish Civil War without actually depicting it at all.*

22 "Une Étoile caresse la sein d'une négresse" *(painting-poem), 1938. The association, through poetic evocation, of a line of verse with an image brings Miró close to the Surrealist automatism practiced by the most orthodox members of the group around Breton.*

19

20

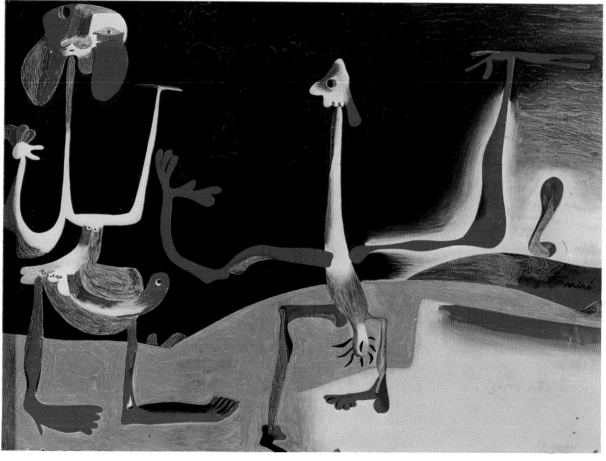

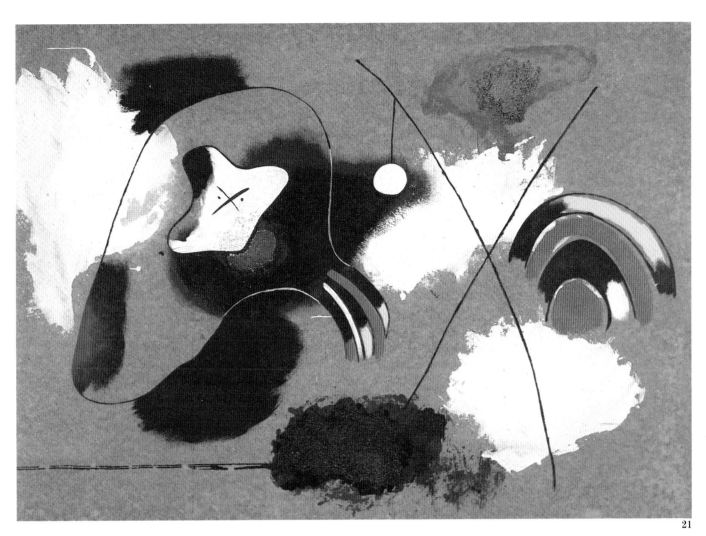

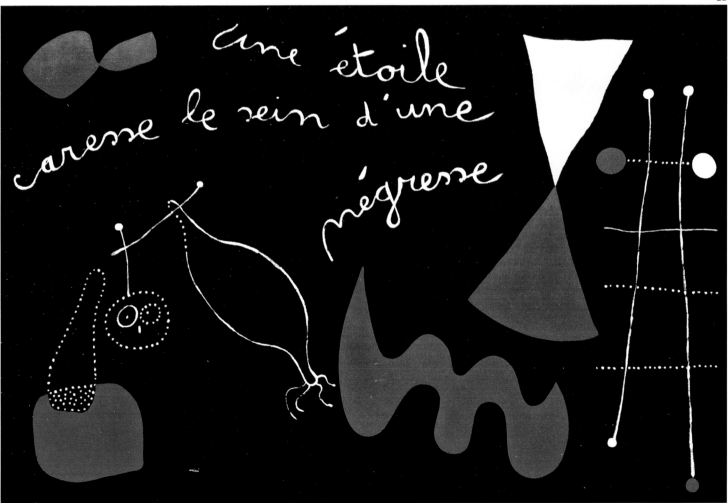

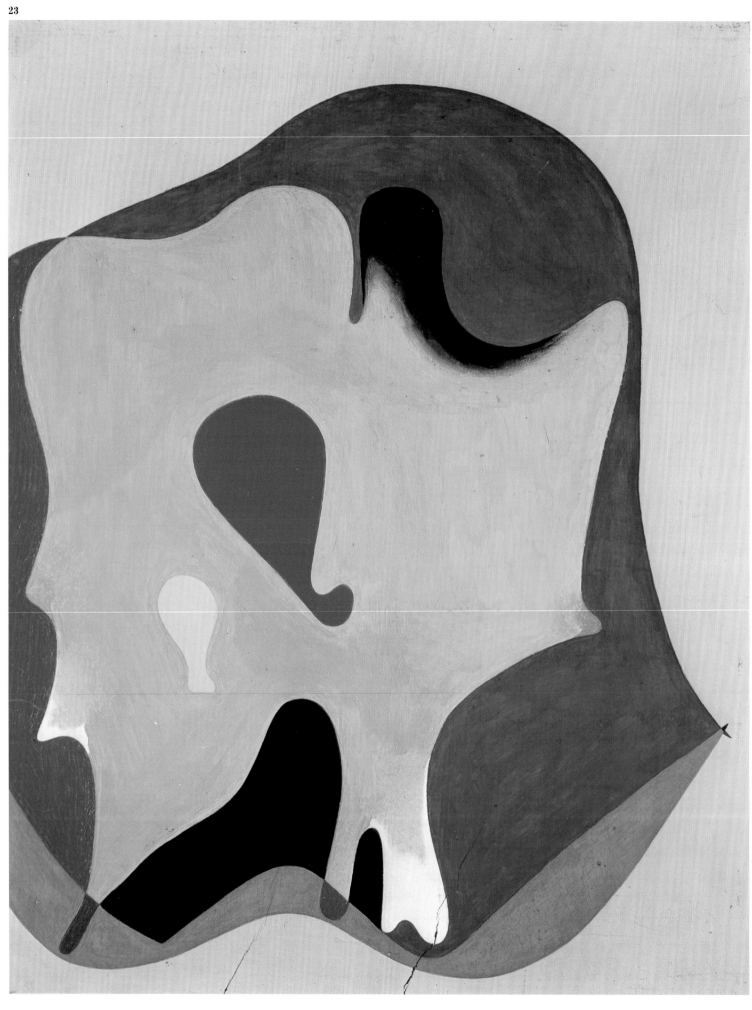

23 Head of a Man, *1932. The shadow on the top of the head introduces an ambiguous suggestion of three-dimensional volume, making it easy to confuse the figure with the background. The image is reminiscent of the work of Pau Gargallo, the sculptor with whom Miró shared a studio on the rue Blomet for some time.*

24 Woman and Dog in Front of the Moon, 1936. *A relation to one of the female figures in Picasso's* Guernica, *painted a year later, is evident. Both paintings express the extreme torment of the victims of war. The same dramatic treatment of the figure is repeated in the poster Miró designed entitled* "Aidez l'Espagne" *and in* The Reaper, *a work that was lost during the war and which had been exhibited along with* Guernica *in the Spanish Pavilion of the 1937 Paris World's Fair.*

24

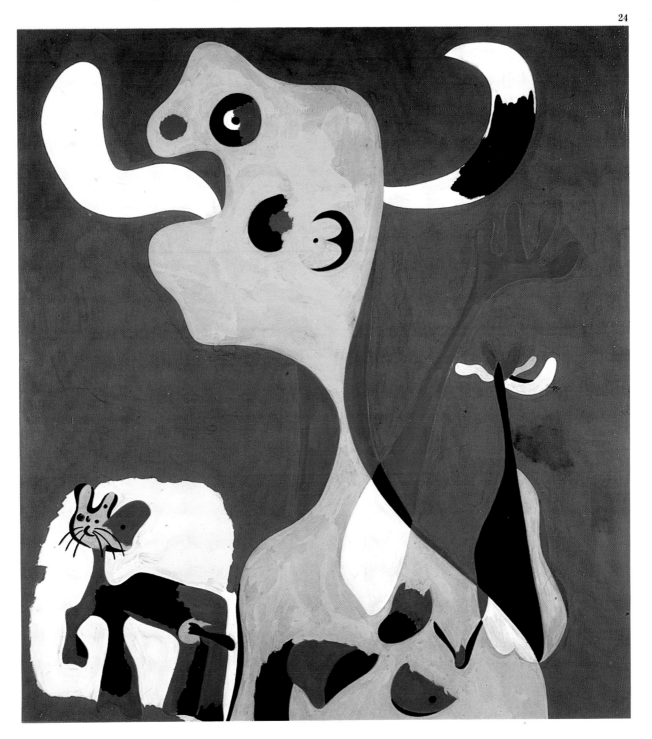

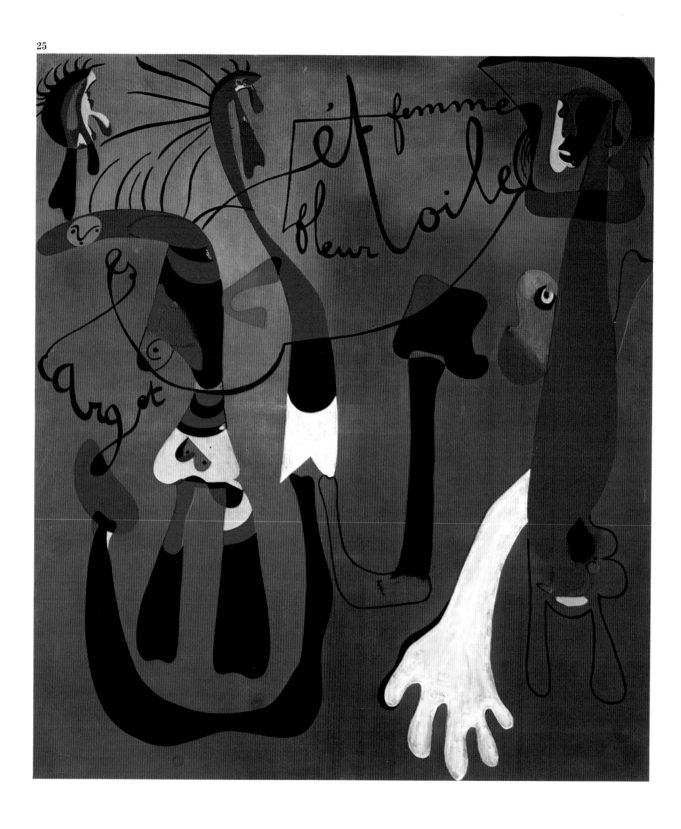

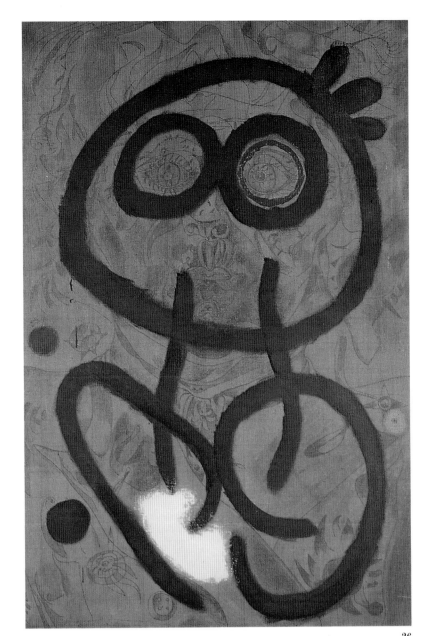

25 "Escargot, femme, fleur, étoile" *(tapestry cartoon), 1934. The body's limbs once again are elongated, as in* Man and Woman in Front of a Pile of Excrement *(plate 20), where the horizon line accentuated the drama even further. Women and celestial bodies were two of Miró's main themes. Here, they both hang suspended in the air without any horizon line behind them, thus announcing the liberation of pictorial space sought by the artist throughout his career.*

26 Self-Portrait, *1937–60. The underlying self-portrait, complicated and meticulous, which was done in pencil with small touches of oil paint in 1937, contrasts with the free, confident strokes added twenty-three years later. In both cases, great importance is given to the eyes. Miró incorporated disembodied eyes in the form of a pictogram into many of his works.*

27 Untitled, *1936. The use of a medium less thick and greasy than oil paint resulted here in a flat, linear, and angular style.*

26

27

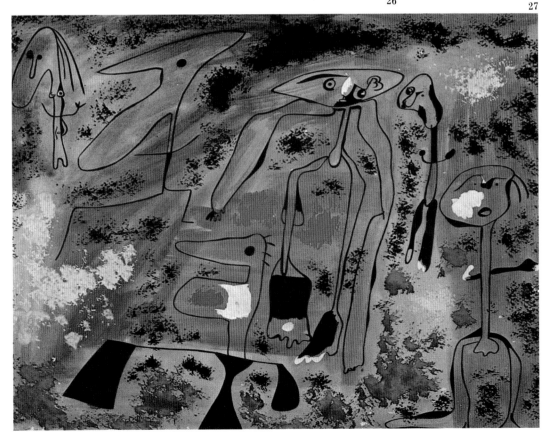

28 Portrait II, *1938. In contrast with the tragic
realism of the underlying image in* Self-Portrait
*(plate 26), in this self-portrait Miró depicted himself
as a simplified, symbolic figure, lacking detail, but
again the eyes were given special prominence.*

29 Painting with an Art Nouveau Frame, *1943. The
Art Nouveau frame seen here, which Joan Prats had
acquired in Barcelona, impressed Miró. He borrowed
it from Prats and after some time returned it to him
with the present painting in it.*

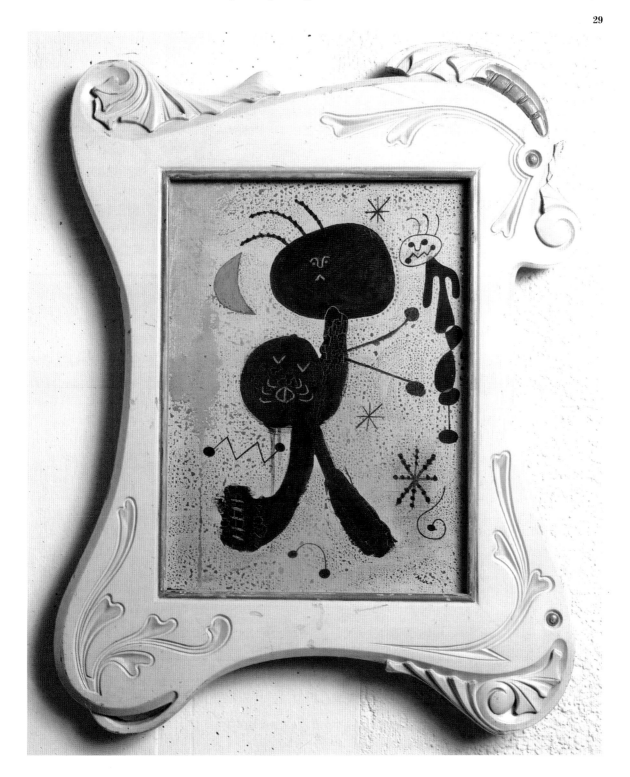

The Constellations

Miró had settled with his family in the small town of Varengeville on the coast of Normandy in 1939, and he would remain there until the advance of the German army made him decide to return to Spain the following year. A series of twenty-three small works on paper, painted in 1940 and 1941 and known as the Constellations, captures both his desire to escape a hostile reality and his response to the landscape and light of Normandy, so different from his usual Mediterranean surroundings. The sky and stars are the leitmotifs of this series. A tangle of lines and small, colored ideograms suggesting birds, allegorical characters, stars, and animals enlivens a vivid, textured surface. This imagery of the heavens led the painter to expand his sense of pictorial space. Despite their small format, these works look ahead to the system of organization of the large canvases, and many of the smaller ones, after 1941.

30 Woman with Blond Armpit Combing Her Hair by the Light of the Stars, *1940. This is one of the Constellations that Miró painted while in Varengeville. He still tended to concentrate the motifs at the center, freeing the edges. The central figure focuses the composition. The sky is a linear setting tying the figure to the background.*

30

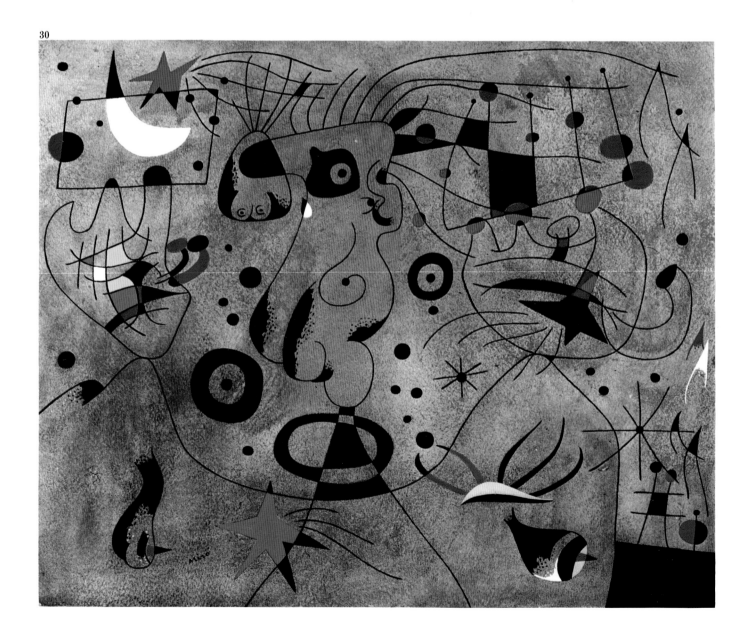

31 Women Encircled by the Flight of a Bird, *1941.*
The stars, each represented by two triangles placed
tip to tip, and the successive positions of the bird
surround the women and extend to the edges of the
painting, weaving a fabric of lines and shapes that
organizes the entire surface of the picture.

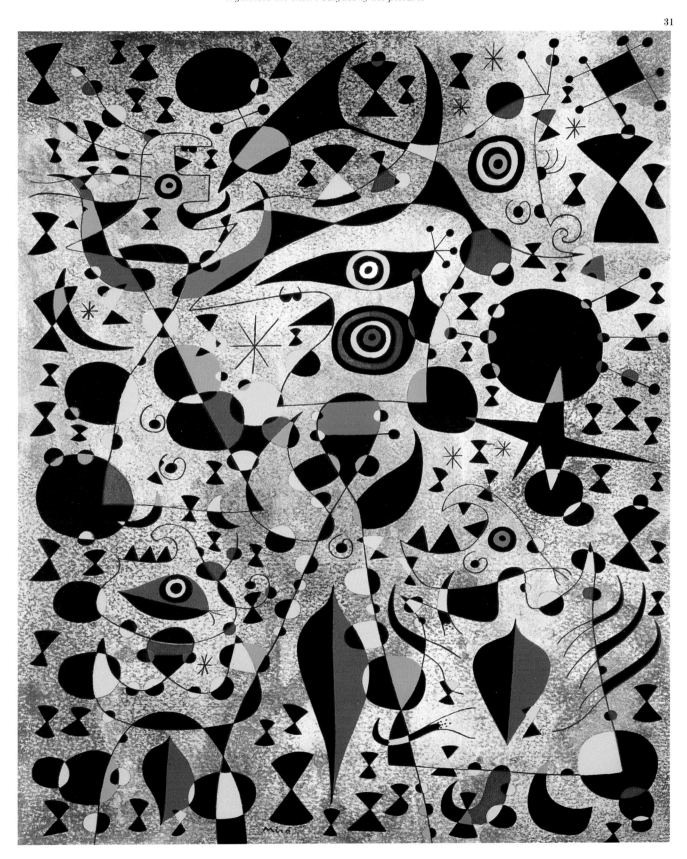

A Language of His Own

After his return to Spain, Miró closed the door on the turbulent period of the Spanish Civil War and on World War II, which was still continuing. His international career began to unfold at his exhibition in New York in 1941. The exhibition brought his fame to the United States at the moment when his pictorial vocabulary, which had been taking shape since the twenties, had matured into a unique language of his own. In the Constellations, he made the whole of the painting into a single, unified surface, integrating the figure with the background. Miró's very personal vocabulary of symbols was perfected by 1945. His paintings from this period are especially notable for their treatment of the background. The color of the background permeates the texture of the surface it is painted on, turning the field of color itself into a pictorial structure.

32 The Red Sun Gnaws at the Spider, *1948. The background of a single well-modulated color and the basic components of Miró's vocabulary—eyes, stars, personages—dominate in this painting done on returning from his first trip to the United States.*

33 Personages in the Night, *1950. Miró's mastery of color and surface texture is evident in a background that integrates greens, ochers, and browns without shading one into the other and leaves the weave of the canvas visible in some areas.*

34 Mural Painting for Joaquim Gomis, *1948. One of Miró's experiments with an unconventional surface, in this case "fibrocement."*

32

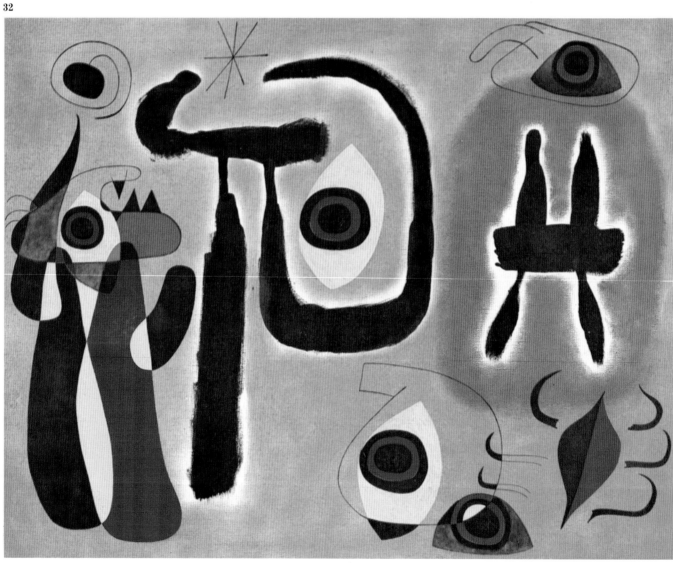

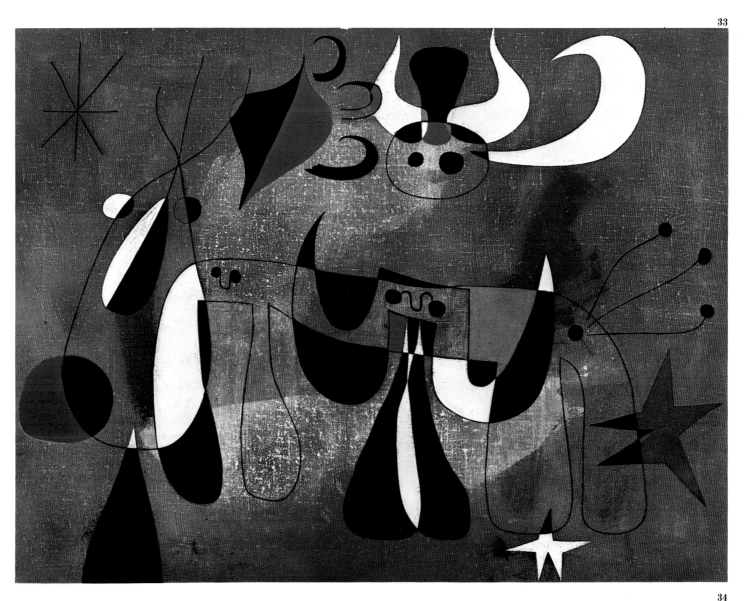

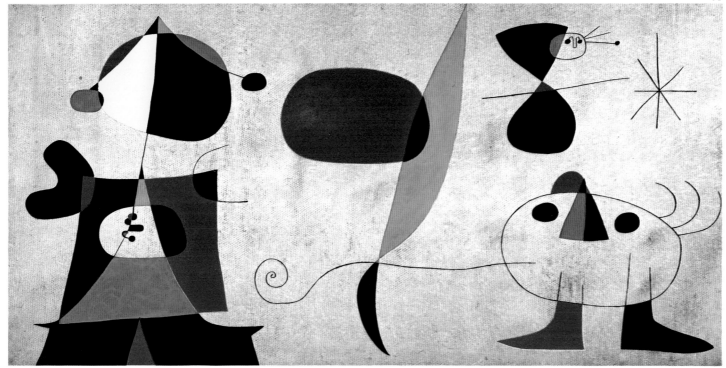

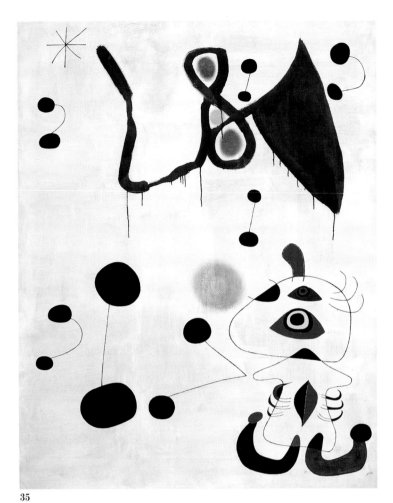

35, 36 Woman and Bird in the Night, *1945;* Woman and Birds at Dawn, *1946. Female personages (who sometimes also have male attributes, as in plate 36), the sun, the birds, and the stars are the expressions of the terrestrial universe alive in Miró's work from the earliest years. Now, however, their significance is not local but cosmic.*

37, 38 Blue II, *1961;* Blue III, *1961. After Miró had gained complete mastery of his resources, he was able to develop subtle interactions between a very large field of a single color and extremely spare lines and shapes, reducing the representational element to a minimum.*

35

36

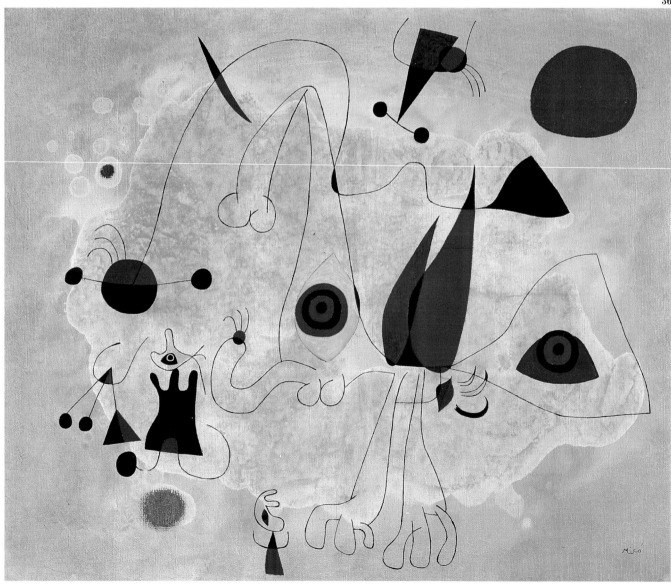

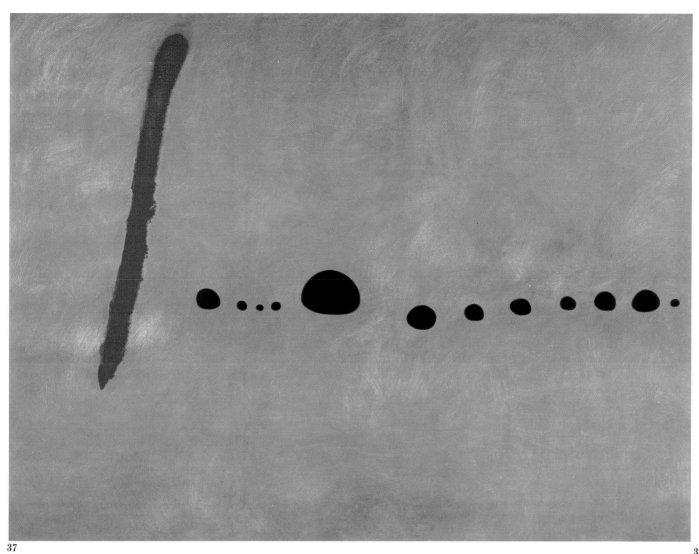

37

Purifying His Style

In 1961, after three trips to the United States and exhibitions at the Galerie Maeght in Paris and the Pierre Matisse Gallery in New York, Miró began further purifying and deepening his earlier discoveries. This development had been heralded by *Blue II* (plate 37) and *Blue III* (plate 38). It reflects, above all, the supreme confidence the artist had attained in composing and coloring his paintings. The style is unmistakable. Miró was playing with codes that describe the movement of objects in a uniquely simple way. For example, a certain trajectory might be represented by a line, generally a thin one, ending in a dot or in a pair of parentheses. This latter symbol was often used by Miró as a kind of container, to keep energy from escaping.

39

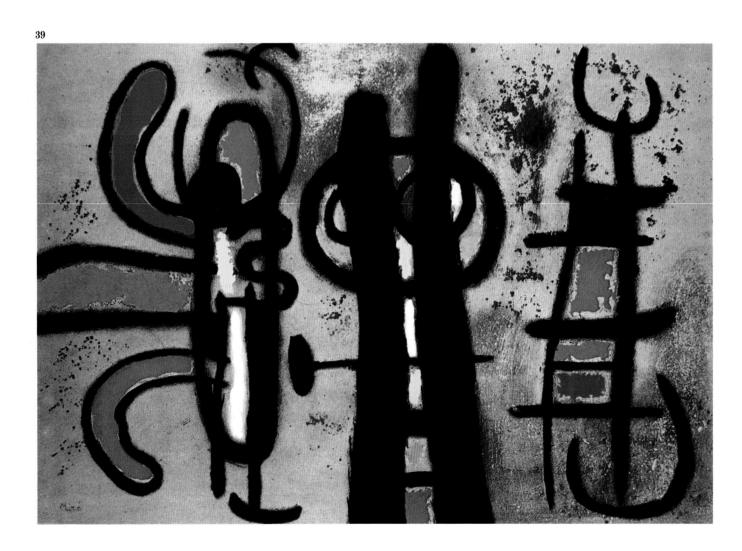

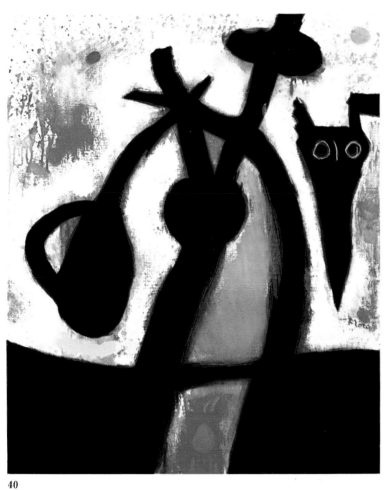

39–41 Personage and Bird, *1963;* Woman and Bird in the Night, *1967;* Personage and Bird, *1963.* *Miró moved ever closer to an intuitive language of almost childlike spontaneity, impossible to reduce to any academic rule. Thick, black, firmly drawn strokes outline the figures and define small areas filled with color that is vibrant and tense, as if it wanted to break out of the boundaries inscribed around it. The horizon line that divided the canvas in two in the twenties has disappeared, making way for a background in which the color and texture of the canvas are masterfully merged.*

40

41

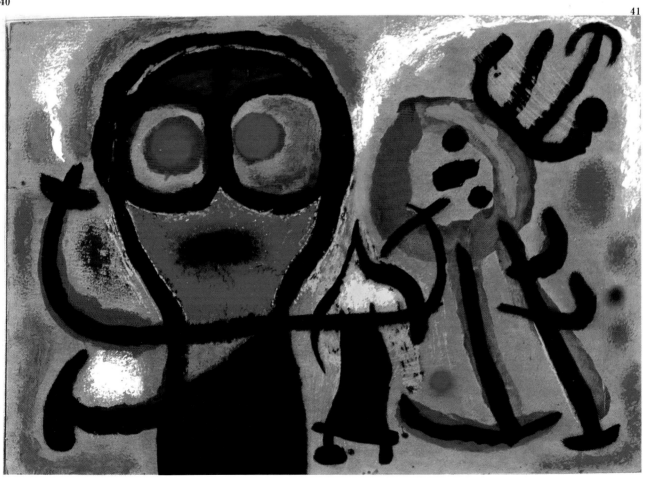

42, 43 For David Fernández Miró, *1964; For Emili Fernández Miró, 1963. The distribution of the colors in checkered spaces reappears in these canvases dedicated to Miró's grandchildren, David and Emili. The elegant fluidity of these works shows the mastery of color and composition that Miró reached in his artistic maturity. The motif is set out across the full length of the canvas with a gentle, undulatory rhythm in which the planes of color mark steady milestones.*

44, 45 The Skiing Lesson, *1966;* Woman III, *1965. Miró never failed to affirm his vocation as a painter. The language of these two paintings is the same as in earlier ones, but the confident brushstrokes of* Woman III *and the delicate, luminous tones of white in* The Skiing Lesson *reveal a growing richness as the artist became more a master of his craft and of his pictorial universe. He transcribed his typical symbols using both firm lines, which frame and contain the colors, and freer brushstrokes.*

42

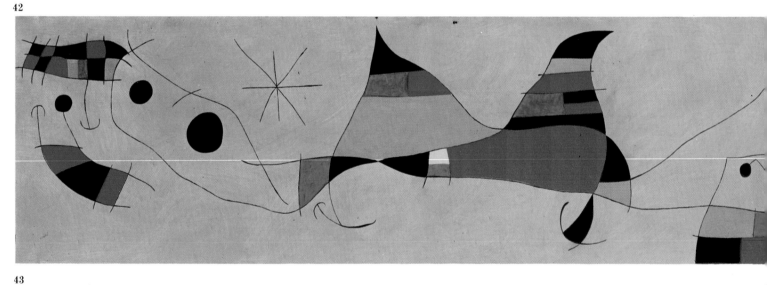

43

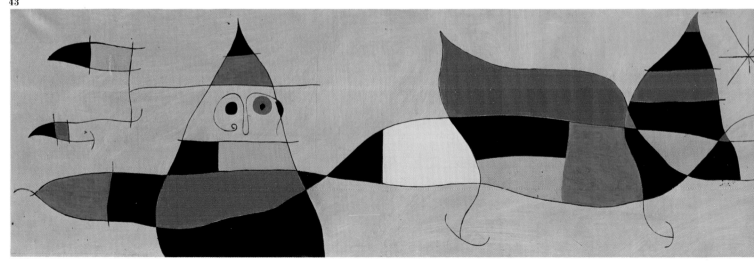

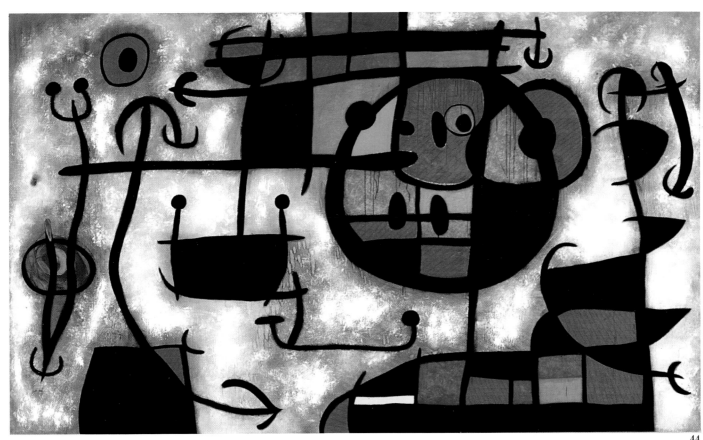

44

45

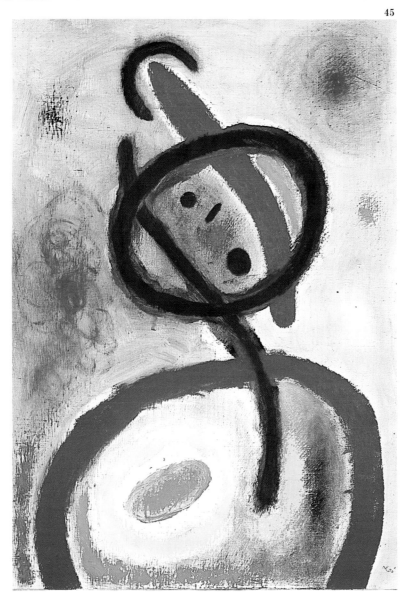

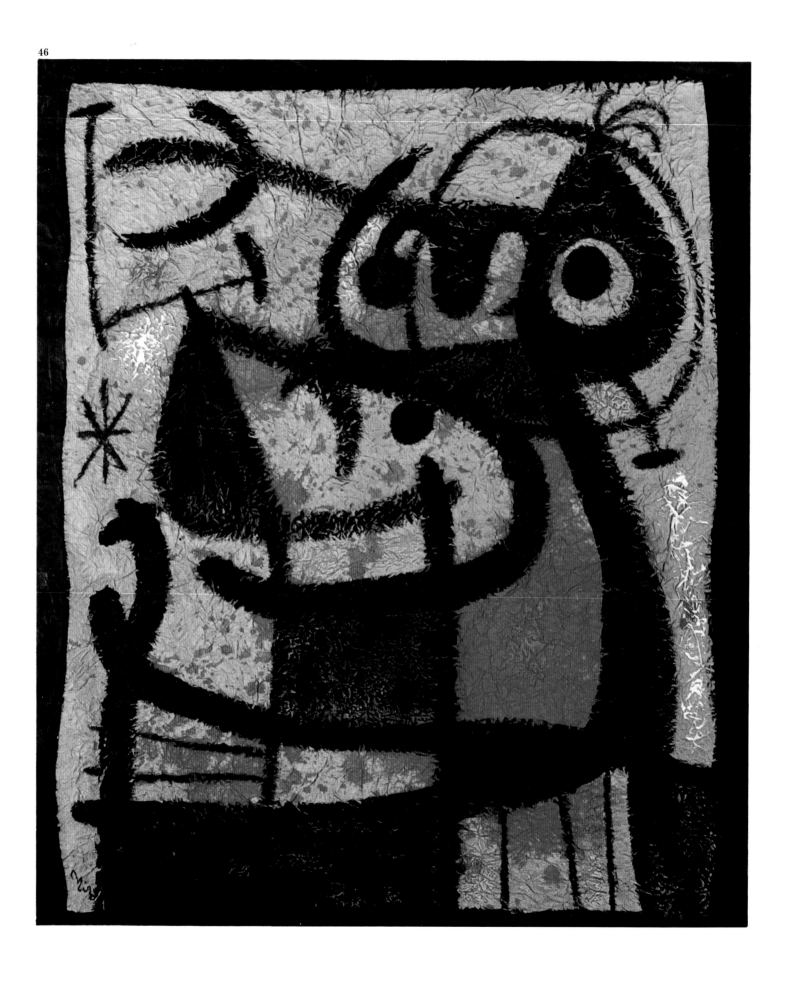

46 Women and Birds, *1967. The painter's concern for attaining different textures in his work was a constant throughout his career. The technique of wet, wrinkled paper, already used in the Constellations, demonstrates this tactile sense, which he discovered as a youth in his teacher Francesc Galí's classes. Galí had him draw objects that he had not seen, but only felt while blindfolded.*

47, 48 The Song of the Vowels, *1966;* Woman and Bird I, *1967. Black, used by Miró especially during the Spanish Civil War, plays a different role in these later convases. Lacking the dramatic content of the earlier period, here it highlights the fluidity of the stroke or provides an elegant background.*

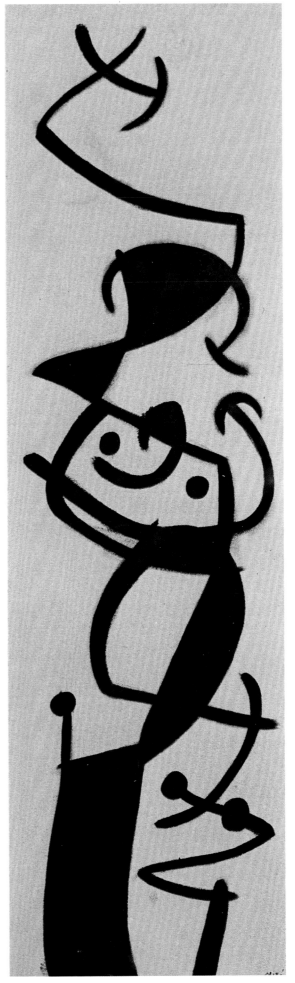

Suns, Planets, Birds

In the mid-sixties, Miró created a series of paintings in which he reduced his stock of expressive means to a minimum. The artist immersed himself in the depths of his own consciousness. In his words, "I fled to the absolute. . . . I wanted my spots of paint to be open to the magnetic beckoning of the void . . . I was interested in the void, in perfect emptiness." Suspended in open fields of dense, vibrant, luminous color were solar disks, the flowing trail of a bird's flight, or the subtle trace of a star. They were all that was necessary to communicate his jubilant introspection on the canvas.

49

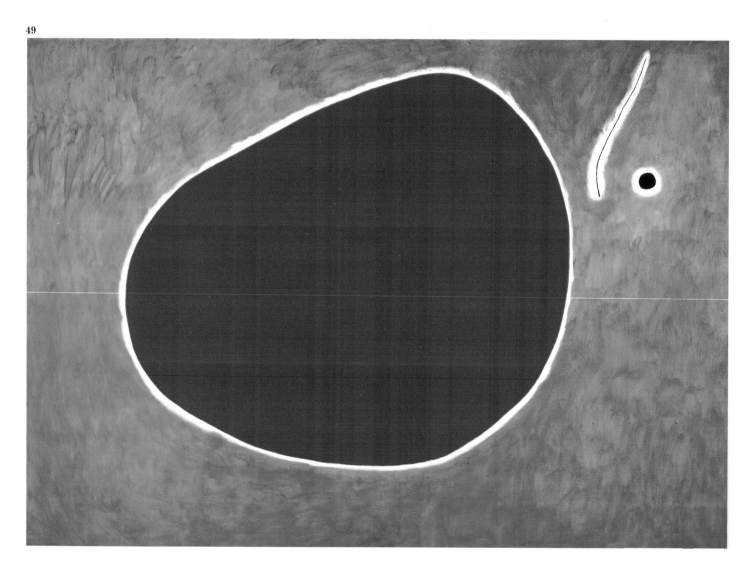

49 The Flight of the Dragonfly in Front of the Sun, *1968. One line is enough to represent the flight of the dragonfly, almost imperceptible before the immensity of the sun but as important as the sun itself in the eyes of the painter.*

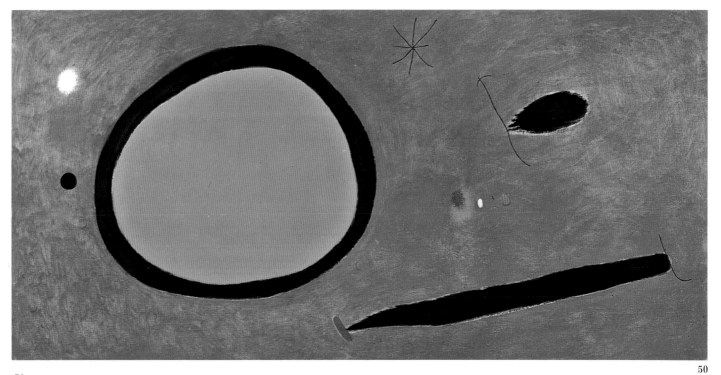

50, 51 The Flight of the Bird in the Light of the Moon, *1967;* Hair Pursued by Two Planets, *1968. Two works in which Miró forgot about the horizon line and delighted in a free space whose limits were set by color, and whose freshness and energy are surprising, considering that he was by this time in his seventies. It was emptiness that now attracted the artist, but an emptiness that was liberating and joyful.*

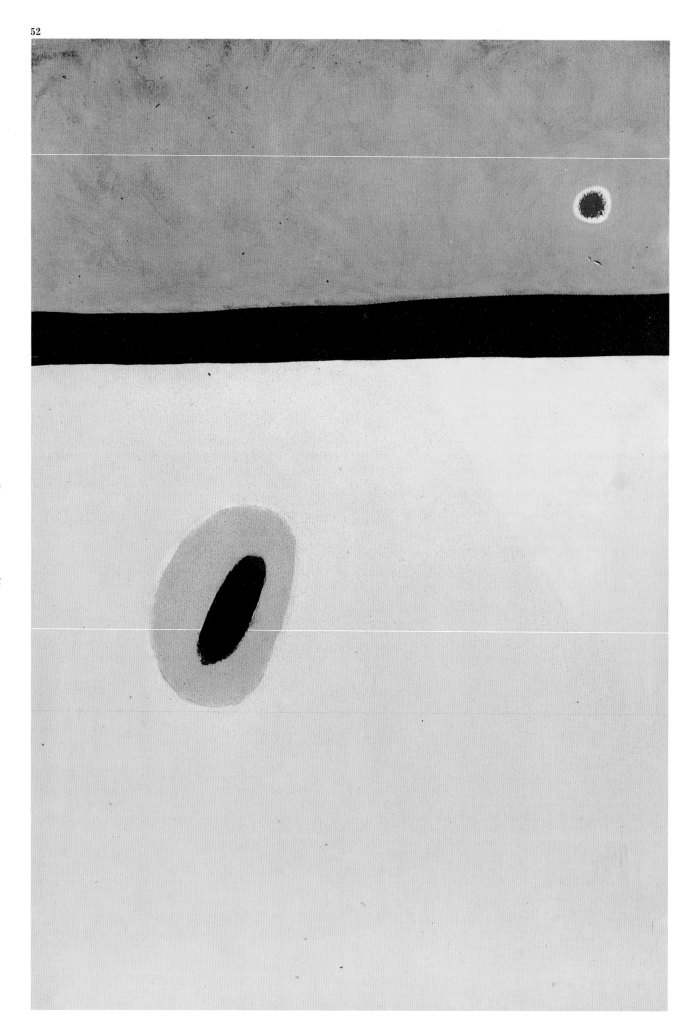

52 The Wing of
the Lark Haloed
with Golden Blue
Reaches the Heart
of the Poppy
Napping on the
Field Adorned with
Diamonds, *1967.*
The black line is
reminiscent of the
horizon in earlier
paintings, but
it is now only an
imaginary instead
of a physical
division.

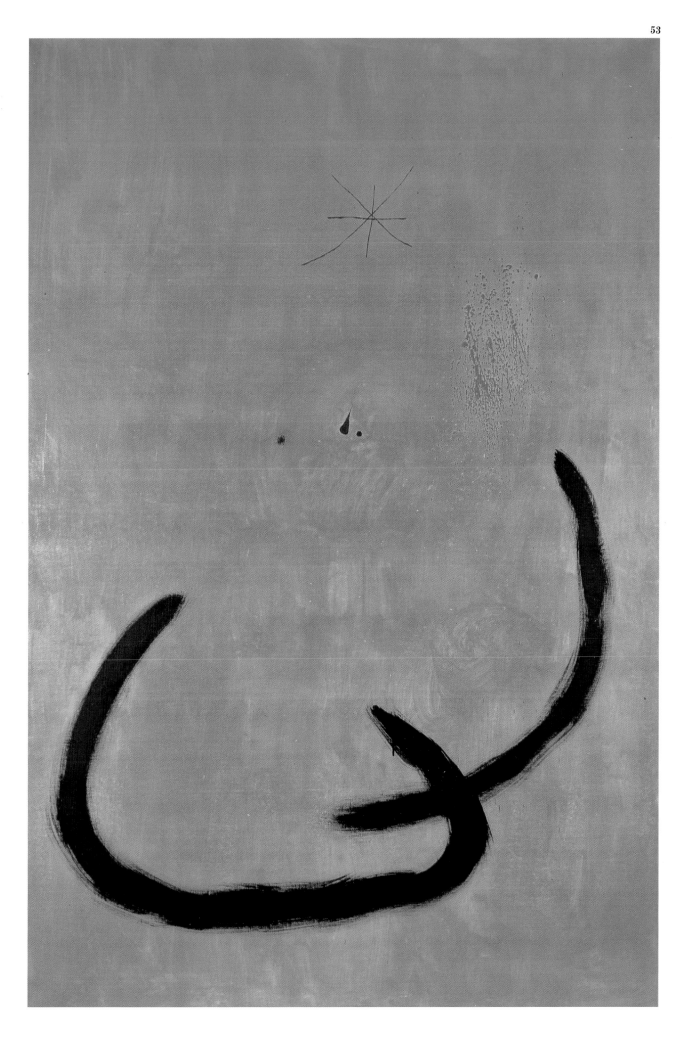

53 Drop of Water on the Pink Snow, *1968. The liberation of the paint is absolute in these works, in which short strokes activate and give meaning to great empty spaces of vibrant color, which suggest an ultimate, luminous essence.*

Final Years

The final years of Miró's artistic career were characterized by an abundant use of black and a loose manner of applying paint to the canvas, which resulted in much dripping and splattering. In the seventies, exhibitions of his work became increasingly frequent and he was honored all over the world. The immediacy of his best paintings today remains inimitable. The primal themes he pursued—the earth, the sky, the human personage transformed—and the means he used to express them—compositional simplicity, sure, confident brushstrokes, mainly primary colors—established one of the most important bodies of work in twentieth-century art.

54

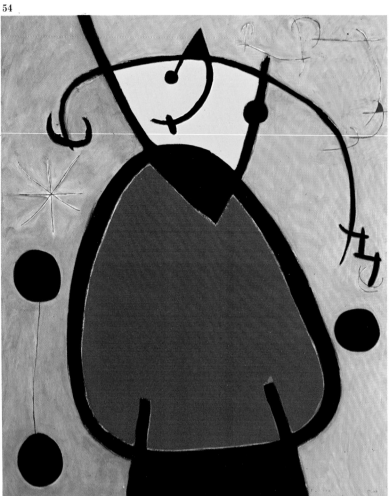

55

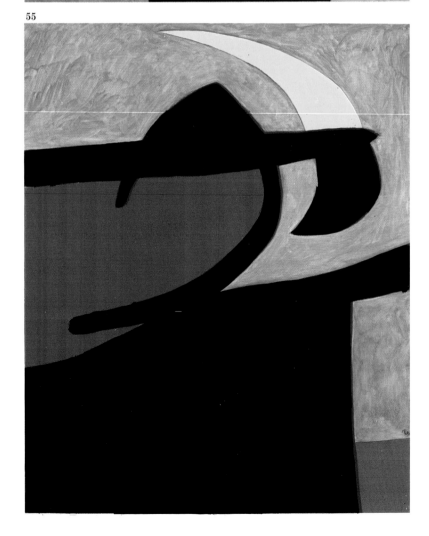

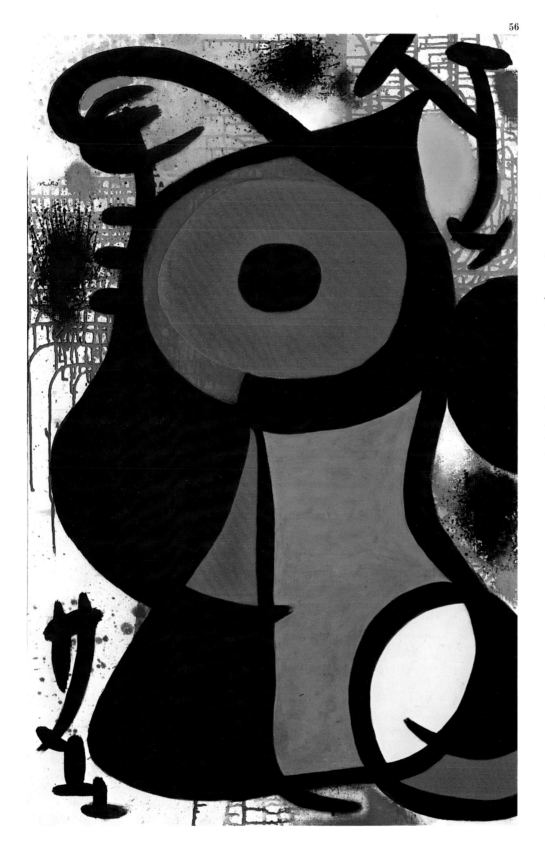

54–56 Woman and Birds in the Night, *1968;* Catalan Peasant in the Light of the Moon, *1968;* Fascinating Personage, *1908. Miró maintained until the very end his dedication to the thematic universe he had formulated as early as* The Farm *(plate 10). The region of Montroig, its peasant farmers, and the mysterious force of nature are combined with symbolic figures whose vital energy is concentrated in the power of vision, expressed in Miró's painting through the prominence of the eye. The planes of flat color alternate in perfect harmony with the drips and the quick brushstrokes.*

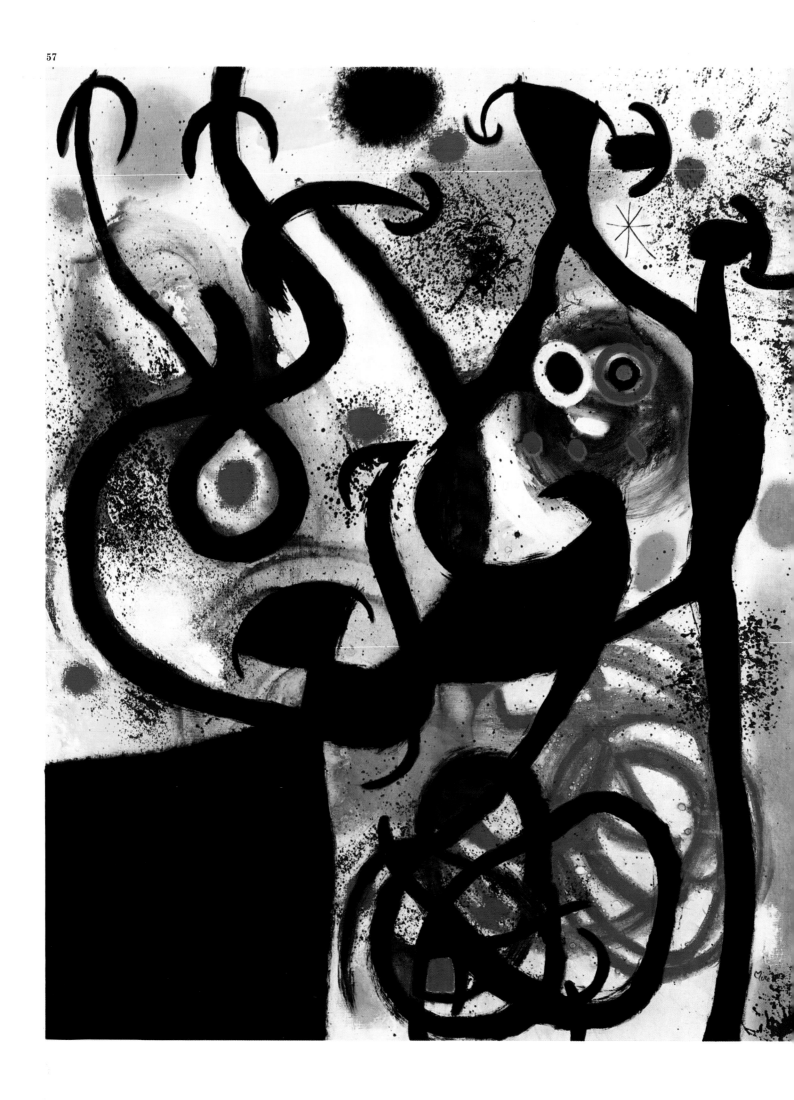

57, 58 Woman and Bird in the Night, *1968; Woman
and Birds in the Night, 1968. In his late works, Miró seems
to review his whole learning process by recovering the
primitive violence of the linear brushstroke used in his
paintings of the war era. His liking for strong lines is
seen in the numerous thick black ones that stand out
on backgrounds of flat white or on surfaces splattered
with paint.*

58

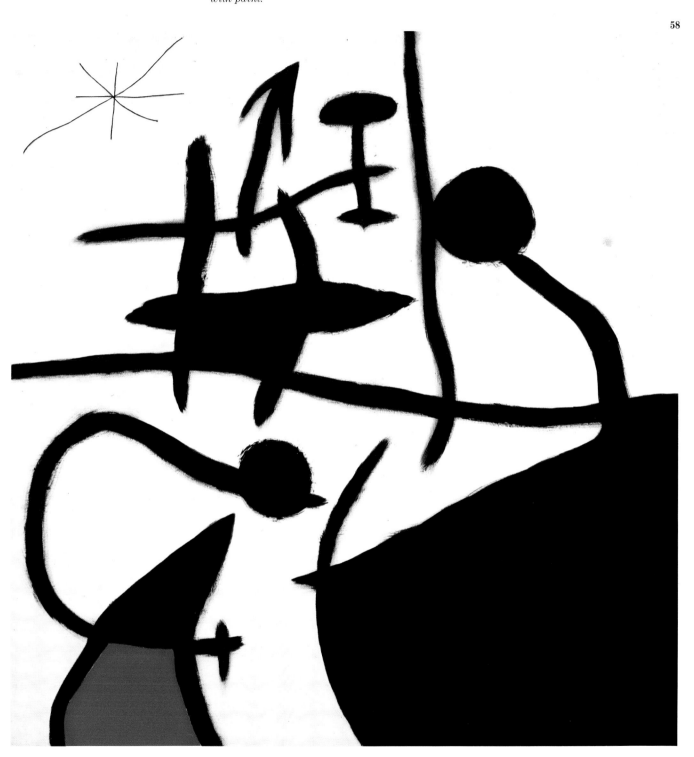

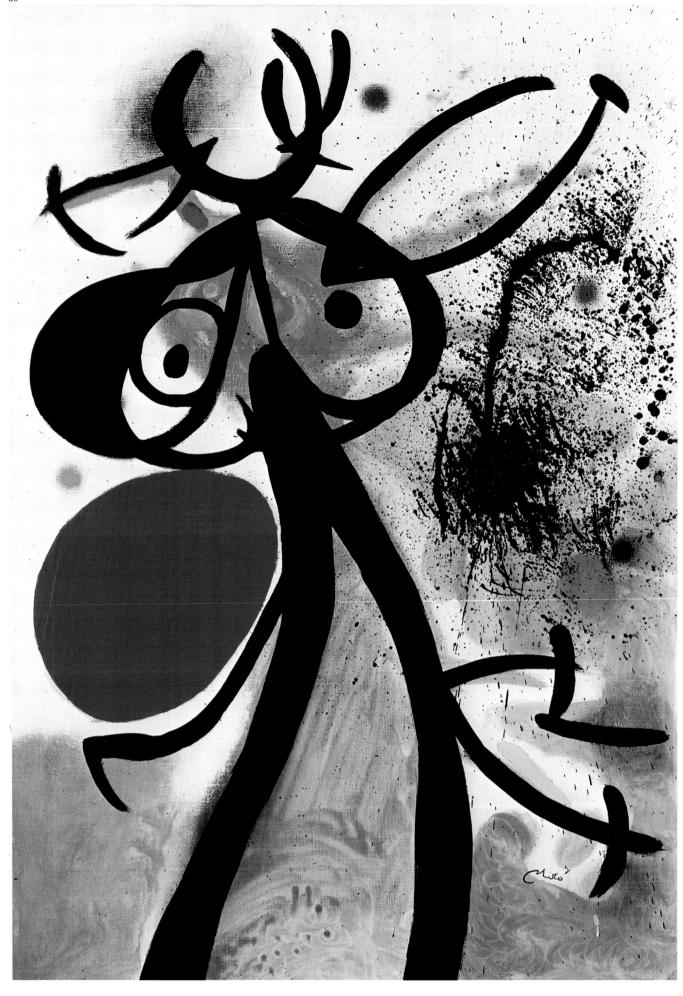

59 Woman and Bird in Front of the Sun, *1972. The unmistakable characters inhabiting Miró's personal universe were increasingly reduced to their basic symbolic features. Scale was not important; women, birds, and stars had become universal pictograms, the language of a world about to be born and which is taking shape before our eyes.*

60 Burned Canvas II, *1973. In the forties, Miró started to experiment with all kinds of pictorial materials. During the final years of his artistic career, after 1970, he allowed himself the freedom to splatter his canvases with paint and even to burn them, creating gaps that allowed the stretcher of the canvas to show through. This revolutionary manifesto came from a man now so confident in his art that he could bring into it any and all methods, however unusual they might seem.*

60

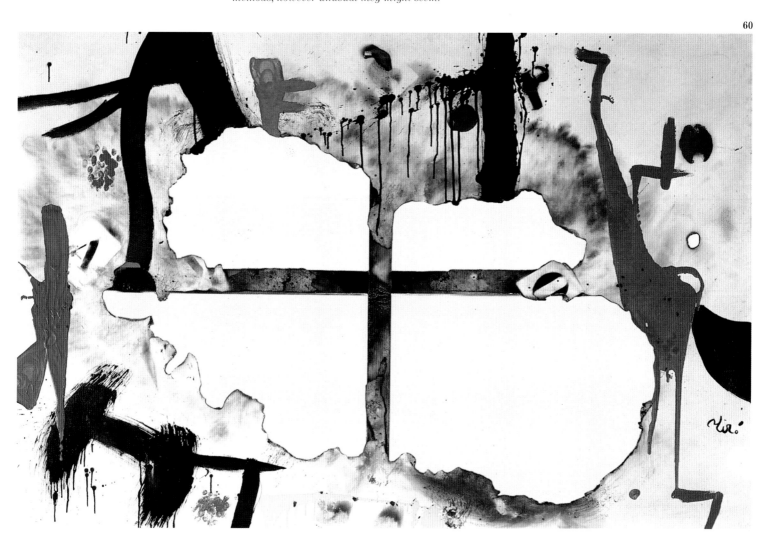

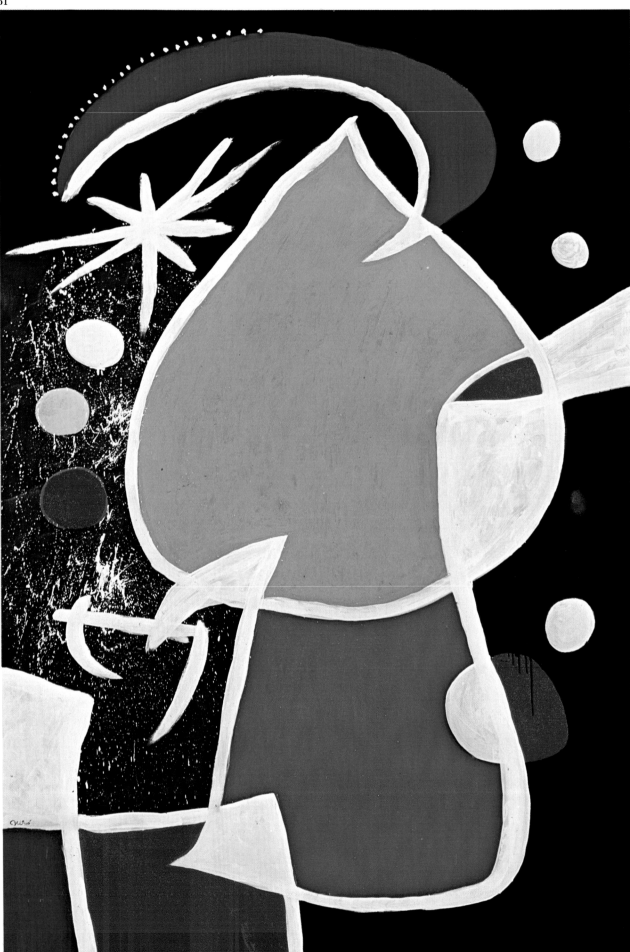

61 Woman in the Night, *1974. The image is presented at times as a negative, inverting the relationship between the figure and the background.*

62 Mask, *1978. Miró's graphic works, such as this lithograph, share the same artistic language as the paintings.*

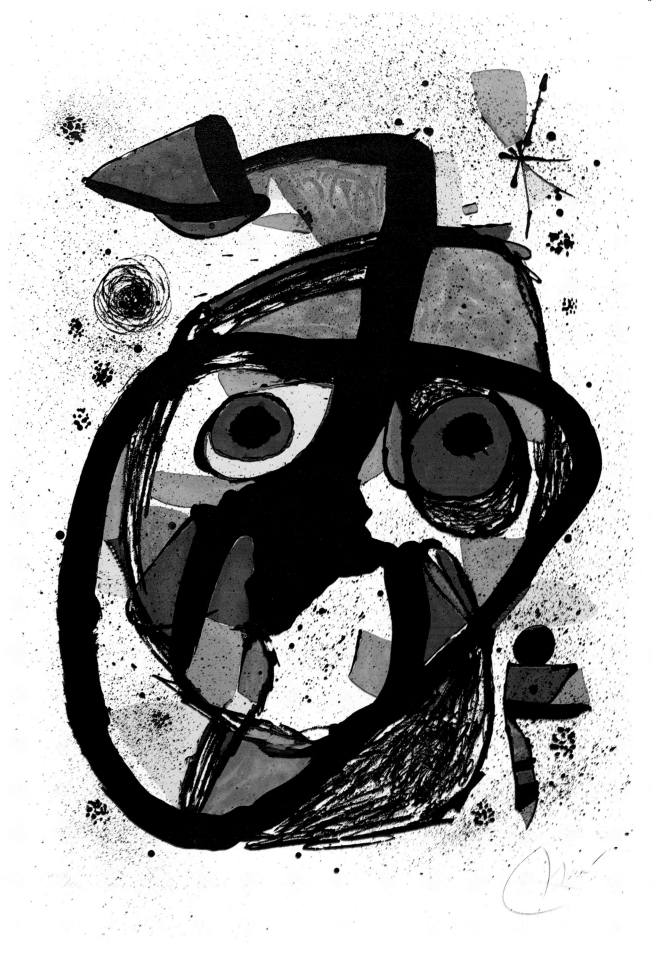

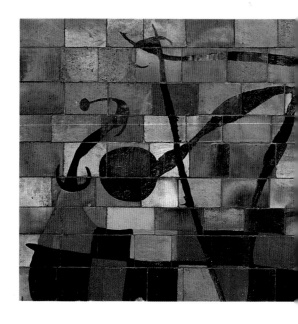

Other Media

Although Miró created his visual language within the field of painting, a portrait of him as an artist is not complete without an examination of his work in related fields, such as sculpture, ceramics, and tapestry. Despite the fact that earlier examples of his work in these media can be found, his devotion to them was consolidated only after 1940. By that time, his personal vocabulary had become well enough established to admit applications other than strictly pictorial ones. Beginning in 1944, he collaborated regularly with the ceramicist Josep Llorens Artigas, whom he had met in 1915, in the production of both small pieces and large decorative murals. In these works, Miró explored the possibilities of this new medium with the experimental mind set that enlivened all his work. The same can be said of his sculpture. He was interested both in exploring volumes and spaces and in the possibility of incorporating everyday objects into his artistic universe, in accord with the Dadaist and Surrealist tradition. He pursued these new interests with an ever youthful enthusiasm. His goal was to broaden the horizons of his art, without succumbing to the easy temptation of resting on the laurels he had won as a painter.

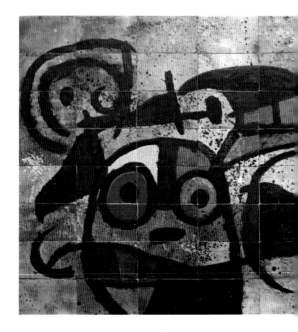

63 Mural of the Moon, *1958. This work and* Mural of the Sun *were commissioned by UNESCO in 1955. Miró exploited to the maximum the technical possibilities of baking the ceramic tiles, in order to achieve a varied and textured background similar to that of the paintings from the same period.*

64 Mural for Harvard University, *1960. Commissioned to replace a wall painting done ten years before, Miró worked directly on the ceramic surface without making a model first, and produced a work of great power.*

65 Mural for IBM, *1976. Although his last ceramic murals are not as arrestingly innovative as his first, they show the sure mastery of the large format that Miró had achieved.*

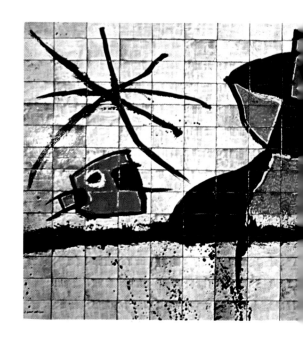

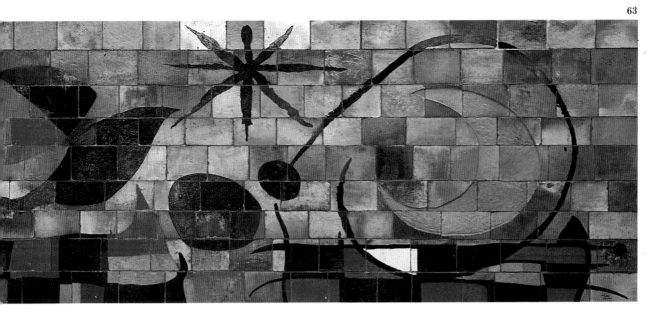

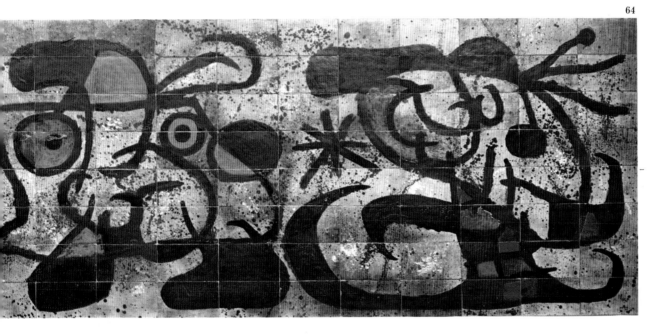

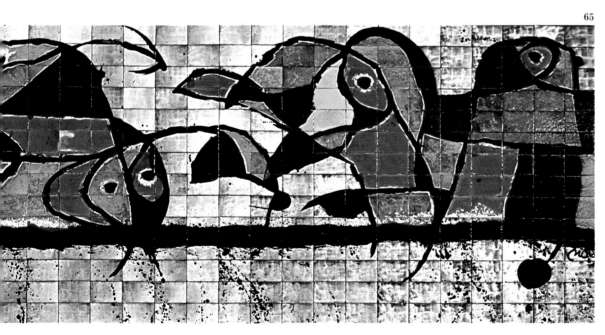

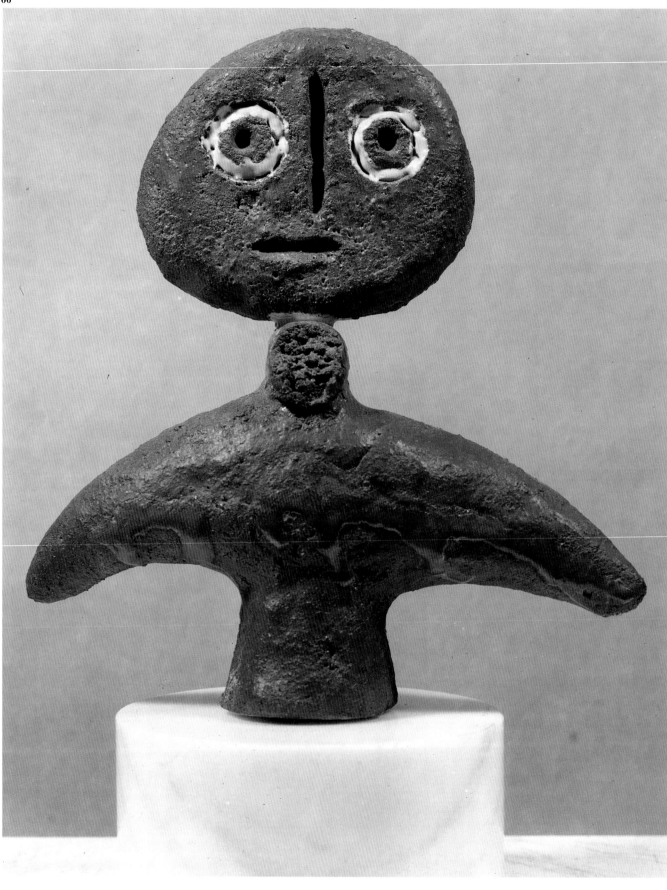

66 The Little Owl, *1956. In the fifties, through small pieces using diverse materials, Miró rediscovered with Josep Llorens Artigas the technical possibilities that ceramics had to offer. The images and the textures evoke the world of idols and of prehistoric Mediterranean terra-cottas, related to the deep bond with his culture that Miró maintained throughout his career.*

67, 68 Woman and Bird, *1967;* Elusive Young Girl, *1968. The integration of found objects into the work belongs to the Dadaist and Surrealist legacy. Miró changed the context of the objects and brought them into his own world. When cast in bronze and painted, the pan, the tricorn, and the faucet transcended mere Surrealist manipulation of the object, taking on a new dimension.*

67

68

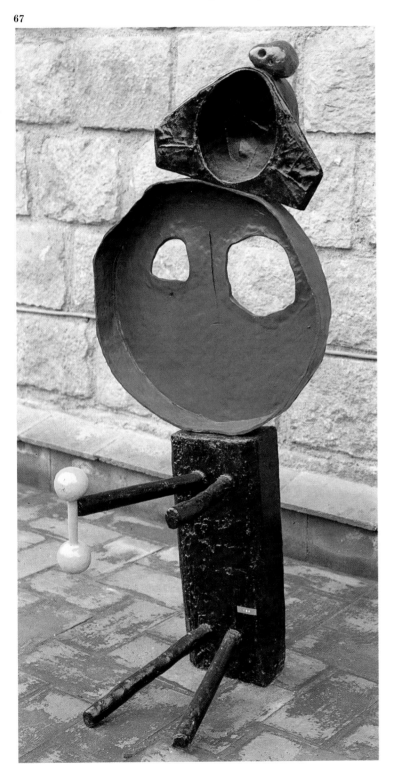

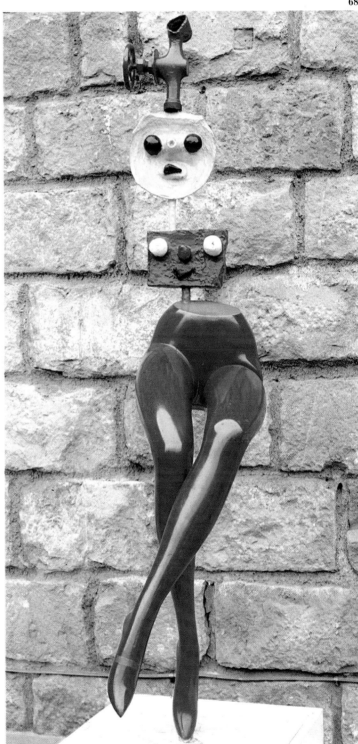

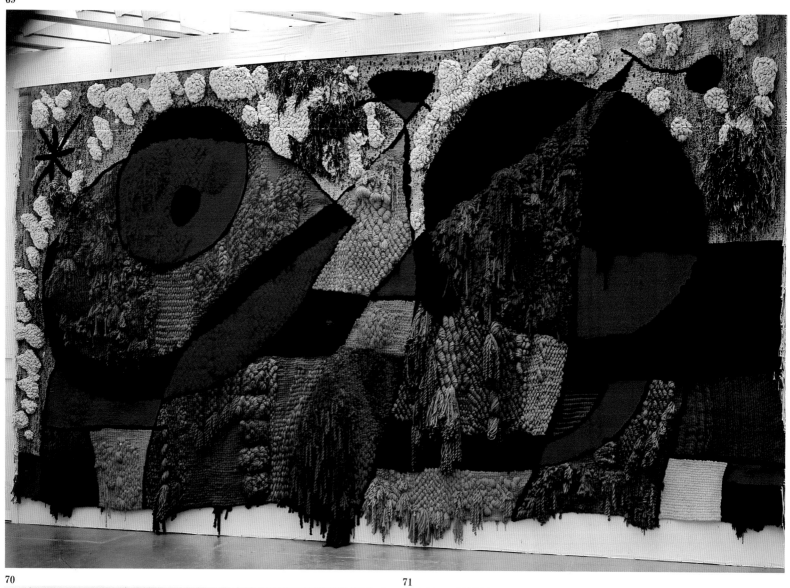

70 71

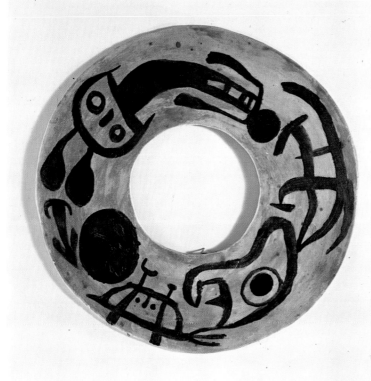

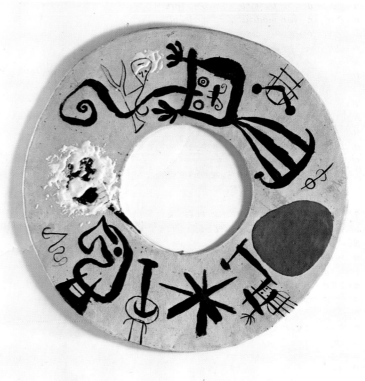

69 Large Tapestry, *1974. This tapestry was intended for the lobby of a New York skyscraper. Miró made a small model of it whose colors and textures were then reinterpreted by the craftsman Josep Royo, Miró's usual collaborator on this kind of textile work.*

70, 71 Anti-Plate, Double-Sided, *1956. Miró's approach to craftsmanship was always characterized by his great respect for the professionals who collaborated with him, in this case Llorens Artigas. Miró never forgot the long crafts tradition in his own family.*

72 Woman and Bird, *1981–82. This monumental sculpture is Miró's last work. Standing in the park in Barcelona now named after him, it includes two of his most characteristic figures, the woman and the bird. The large cement structure covered with ceramic elements prepared by Joan Gardy-Artigas alludes to the decorations of Parc Güell in Barcelona, designed by Antoni Gaudí. The piece constitutes a synthesis of many of the themes, concerns, and influences that animated all the artist's works.*

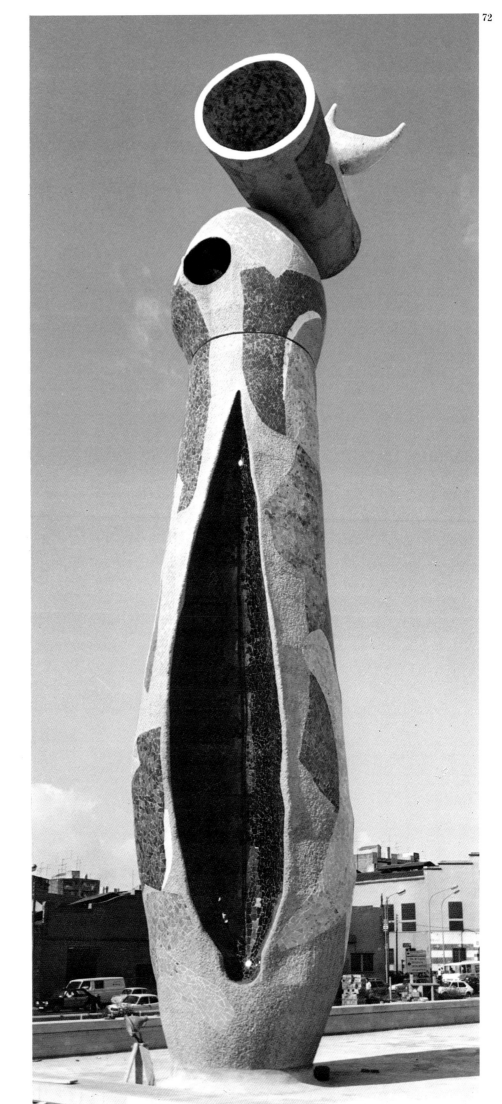

List of Plates

1 "Nord-Sud," *1917. Oil on canvas, 24⅜ × 27⅝" (62 × 70 cm). Collection Paule and Adrien Maeght, Paris*

2 Portrait of Vicente Nubiola, *1917. Oil on canvas, 41 × 44½" (104 × 113 cm). Museum Folkwang, Essen*

3 A Street, Prades, *1917. Oil on canvas, 19½ × 23¼" (49 × 59 cm). Private collection*

4 Ciurana, the Village, *1917. Oil on canvas, 19¼ × 15⅜" (49 × 39 cm). Private collection*

5 Design of a Poster for the Magazine "L'Instant," *1919. Oil on cardboard, 41 × 29¼" (107 × 76 cm). IVAM, Institut Valencià d'Art Modern, Valencia, Spain*

6 The Village of Montroig, *1919. Oil on canvas, 28¾ × 23⅝" (73 × 60 cm). Private collection*

7 Portrait of a Young Girl, *1919. Oil on paper, mounted on canvas, 13¾ × 10⅝" (34.8 × 27 cm). Fundació Joan Miró, Barcelona*

8 Vegetable Garden and Donkey, *1918. Oil on canvas, 25⅛ × 27½" (64 × 70 cm). Moderna Museet, Stockholm*

9 Portrait of a Spanish Dancer, *1921. Oil on canvas, 26 × 22" (66 × 56 cm). Musée Picasso, Paris*

10 The Farm, *1921–22. Oil on canvas, 52 × 57⅞" (132 × 147 cm). National Gallery of Art, Washington, D.C. Gift of Mary Hemingway*

11 Harlequin's Carnival, *1924–25. Oil on canvas, 26 × 37" (66 × 93 cm). Albright-Knox Art Gallery, Buffalo. Room of Contemporary Art Fund*

12 The Tilled Field, *1923–24. Oil on canvas, 26 × 37" (66 × 94 cm). Solomon R. Guggenheim Museum, New York*

13 The Hunter (Catalan Landscape), *1923–24. Oil on canvas, 25 × 39⅜" (65 × 100 cm). The Museum of Modern Art, New York. Purchase*

14 Head of a Smoker, *1925. Oil on canvas, 25 × 19¾" (65 × 50 cm). Museum of Modern Art, Toyama, Japan*

15 Landscape with Snake, *1927. Oil on canvas, 51⅛" × 6' 4¾" (130 × 195 cm). Private collection*

16 Dutch Interior I, *1928. Oil on canvas, 36⅛ × 28¾" (92 × 73 cm). The Museum of Modern Art, New York. Mrs. Simon Guggenheim Fund*

17 Painting Based on a Collage, *1933. Oil on canvas, 51⅜ × 64" (130 × 162 cm). Fundació Joan Miró, Barcelona*

18 Portrait of Mistress Mills in 1750, *1929. Oil on canvas, 46 × 35¼" (116.7 × 89.6 cm). The Museum of Modern Art, New York. James Thrall Soby Bequest*

19 Flame in Space and Nude Woman, *1932. Oil on cardboard, 16⅛ × 12⅝" (41 × 32 cm). Fundació Joan Miró, Barcelona*

20 Man and Woman in Front of a Pile of Excrement, *1935. Oil on copper, 9⅛ × 12⅝" (23.2 × 32 cm). Fundació Joan Miró, Barcelona*

21 Painting on Masonite, *1936. Oil, tar, casein, and sand on masonite, 30¾ × 42⅜" (78.3 × 107.7 cm). Fundació Joan Miró, Barcelona*

22 "Une Étoile caresse la sein d'une negresse" *(painting-poem), 1938. Oil on canvas, 51" × 6' 4½" (129.5 × 194.3 cm). Tate Gallery, London. Purchase*

23 Head of a Man, *1932. Oil on panel, 13¾ × 10⅝" (35 × 27 cm). Private collection*

24 Woman and Dog in Front of the Moon, *1936. Gouache on cardboard, 18 × 17" (50 × 44.5 cm). Private collection*

25 "Escargot, femme, fleur, étoile" *(tapestry cartoon), 1934. Oil on canvas, 6' 4¾" × 67⅝" (195 × 172 cm). Museo Nacional Centro de Arte Reina Sofía, Madrid*

26 Self-Portrait, *1937–60. Oil and pencil on canvas, 57⅝ × 38⅛" (146.5 × 97 cm). Fundació Joan Miró, Barcelona*

27 Untitled, *1936. Pencil, watercolor, and gouache on cardboard, 19⅝ × 25⅛" (49.8 × 64.6 cm). Fundació Joan Miró, Barcelona*

28 Portrait II, *1938. Oil on canvas, 63¾ × 51⅛" (162 × 130 cm). Museo Nacional Centro de Arte Reina Sofía, Madrid*

29 Painting with an Art Nouveau Frame, *1943. Oil and pastel on canvas, 15¾ × 11¾" (40 × 30 cm). Fundació Joan Miró, Barcelona*

30 Woman with Blond Armpit Combing Her Hair by the Light of the Stars *(from the Constellations series), 1940. Gouache and oil wash on paper, 15 × 18⅛" (38.1 × 46 cm). The Cleveland Museum of Art. Contemporary Collection*

31 Women Encircled by the Flight of a Bird *(from the Constellations series), 1941. Gouache and oil wash on paper, 18⅛ × 15" (46 × 38 cm). Private collection*

32 The Red Sun Gnaws at the Spider, *1948. Oil on canvas, 30 × 37¾" (76 × 96 cm). Private collection*

33 Personages in the Night, *1950. Oil on canvas, 35 × 45¼" (89 × 115 cm). Private collection, New York*

34 Mural Painting for Joaquim Gomis, *1948. Oil on fibrocement, 49" × 8' 3" (125 × 250 cm). Masaveu Collection, Oviedo*

35 Woman and Bird in the Night, *1945. Oil on canvas, 57½ × 44⅞" (146 × 114 cm). Fundació Joan Miró, Barcelona*

36 Woman and Birds at Dawn, *1946. Oil on canvas, 21¼ × 25⅝" (54 × 65 cm). Fundació Joan Miró, Barcelona*

37 Blue II, *1961. Oil on canvas, 8' 10¼" × 11' 7¾" (270 × 355 cm). Musée National d'Art Moderne, Centre Georges Pompidou, Paris. Gift of the Menil Foundation*

38 Blue III, *1961. Oil on canvas, 8' 9½" × 11' 5⅜"*
(268 × 349 cm). Musée National d'Art Moderne, Centre Georges
Pompidou, Paris

39 Personage and Bird, *1963. Oil on cardboard, 29½ × 41⅜"*
(75 × 105 cm). Private collection

40 Woman and Bird in the Night, *1967. Oil on canvas,*
28¾ × 23⅝" (73 × 60 cm). Private collection

41 Personage and Bird, *1963. Oil on cardboard, 29½ × 41⅜"*
(75 × 105 cm). Bergen Art Museum. Stenersens Samling, Bergen,
Norway

42 For David Fernández Miró, *1964. Oil on canvas,*
29½" × 9' 2¼" (75 × 280 cm). Private collection

43 For Emili Fernández Miró, *1963. Oil on canvas,*
29½" × 9' 2¼" (75 × 280 cm). Fundació Pilar i Joan Miró,
Palma de Mallorca

44 The Skiing Lesson, *1966. Oil on canvas, 6' 4¾" × 10' 7½"*
(195 × 324 cm). Museo de Arte Contemporáneo, Caracas

45 Woman III, *1965. Oil on canvas, 45¾ × 31¾" (116 × 81 cm).*
Fundació Joan Miró, Barcelona

46 Women and Birds, *1967. Oil on wrinkled kraft paper,*
35⅞ × 29⅛" (91 × 74 cm). Private collection

47 The Song of the Vowels, *1966. Oil on canvas, 12' ⅛" × 45¼"*
(366 × 114.8 cm). The Museum of Modern Art, New York.
Mrs. Simon Guggenheim Fund, special contribution in honor of
Dorothy C. Miller

48 Woman and Bird I, *1967. Oil on sandpaper, 6' 7⅞" × 23⅝"*
(203 × 60 cm). Private collection

49 The Flight of the Dragonfly in Front of the Sun, *1968. Oil on*
canvas, 68½" × 8" (174 × 244 cm). National Gallery of Art,
Washington

50 The Flight of the Bird in the Light of the Moon, *1967. Oil on*
canvas, 51¼" × 8' 6⅜" (130 × 260 cm). Private collection

51 Hair Pursued by Two Planets, *1968. Oil on canvas,*
6' 4" × 51" (195 × 130 cm). Collection Gallery K. AG. On loan at
the Fundació Joan Miró, Barcelona

52 The Wing of the Lark Haloed with Golden Blue Reaches the
Heart of the Poppy Napping on the Field Adorned with Diamonds,
1967. Oil on canvas, 6' 2" × 50¼" (192.5 × 127.5 cm). Collection
Gallery K. AG. On loan at the Fundació Joan Miró, Barcelona

53 Drop of Water on the Pink Snow, *1968. Oil on canvas,*
6' 4" × 51" (195 × 130 cm). Private collection

54 Woman and Birds in the Night, *1968. Oil on canvas,*
63¾ × 51" (162 × 130 cm). Private collection

55 Catalan Peasant in the Light of the Moon, *1968. Oil on*
canvas, 63¾ × 51¼" (162 × 130 cm). Fundació Joan Miró,
Barcelona

56 Fascinating Personage, *1968. Oil on canvas, 41¾ × 28¾"*
(106 × 73 cm). Private collection

57 Woman and Bird in the Night, *1968. Oil on canvas,*
57½ × 44⅞" (146 × 114 cm). Private collection

58 Woman and Birds in the Night, *1968. Oil on canvas,*
6' 8⅝" × 6' 4¾" (205 × 195 cm). Private collection

59 Woman and Bird in Front of the Sun, *1972. Oil on canvas,*
45½ × 31⅝" (116 × 81 cm). Private collection

60 Burned Canvas II, *1973. Oil on canvas, later perforated and*
burned, 51" × 6' 4" (130 × 195 cm). Fundació Joan Miró,
Barcelona

61 Woman in the Night, *1974. Oil on canvas, 6' 4" × 51"*
(194 × 130 cm). Museo de la Diputación Foral de Alava, Vitoria,
Spain

62 Mask, *1978. Color lithograph, 22 × 29⅞" (56 × 76 cm)*

63 Mural of the Moon, *1958. Ceramic, 9' 8" × 24' 6"*
(3 × 7.5 m). UNESCO Building, Paris

64 Mural for Harvard University, *1960. Ceramic, 6' 6" × 19' 7"*
(2 × 6 m). Harkness Commons, Harvard University, Cambridge,
Massachusetts

65 Mural for IBM, *1976. Ceramic, 9' 2" × 28' 5" (2.8 × 8.7 m).*
Realized with Joan Gardy-Artigas, Gallifa. IBM Building,
Barcelona

66 The Little Owl, *1956. Ceramic, 7½ × 6⅝" (19 × 17 cm)*

67 Woman and Bird, *1967. Painted bronze, 47¼ × 19¾ × 17¾"*
(120 × 50 × 45 cm). Realized with the Clementi foundry,
Meudon. Fundació Joan Miró, Barcelona

68 Elusive Young Girl, *1968. Painted bronze, 7' 1" × 19¾ × 22"*
(216 × 50 × 56 cm). Realized with the Susse foundry, Arcueil.
Fundació Joan Miró, Barcelona

69 Large Tapestry, *1974. Wool, hemp, and string, 19' 7" × 36'*
(6 × 11 m). Port Authority, New York

70–71 Anti-Plate, Double-Sided, *1956. Ceramic, 19¾" (50 cm)*
diameter

72 Woman and Bird, *1981–82. Cement with ceramic fragments,*
72' (22 m) high. Realized with Joan Gardy-Artigas. Parc Joan
Miró (Plaça de l'Escorxador), Barcelona

Selected Bibliography

Dupin, Jacques. *Miró*. Barcelona: Ediciones Polígrafa; New York:
 Harry N. Abrams, Inc., 1993.

Joan Miró, 1893/1993. Barcelona: Fundació Joan Miró; Boston
 and New York: Little, Brown, 1993.

Krauss, Rosalind, and Margit Rowell. *Joan Miró: Magnetic Fields*.
 New York: Solomon R. Guggenheim Museum, 1972.

Lanchner, Carolyn. *Joan Miró*. New York: The Museum of Modern
 Art, 1993.

Penrose, Roland. *Miró*. London: Thames & Hudson, 1990.

Rowell, Margit, ed. *Joan Miró: Selected Writings and Interviews*.
 Boston: G. K. Hall, 1986.